The Ir

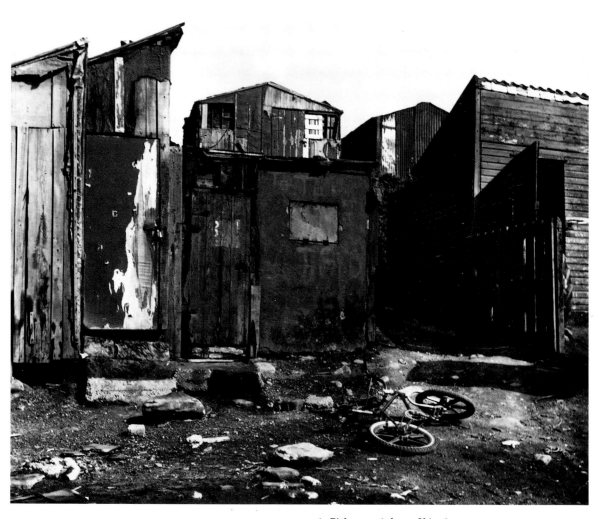

1 *Fishermen's huts, Skinningrove*

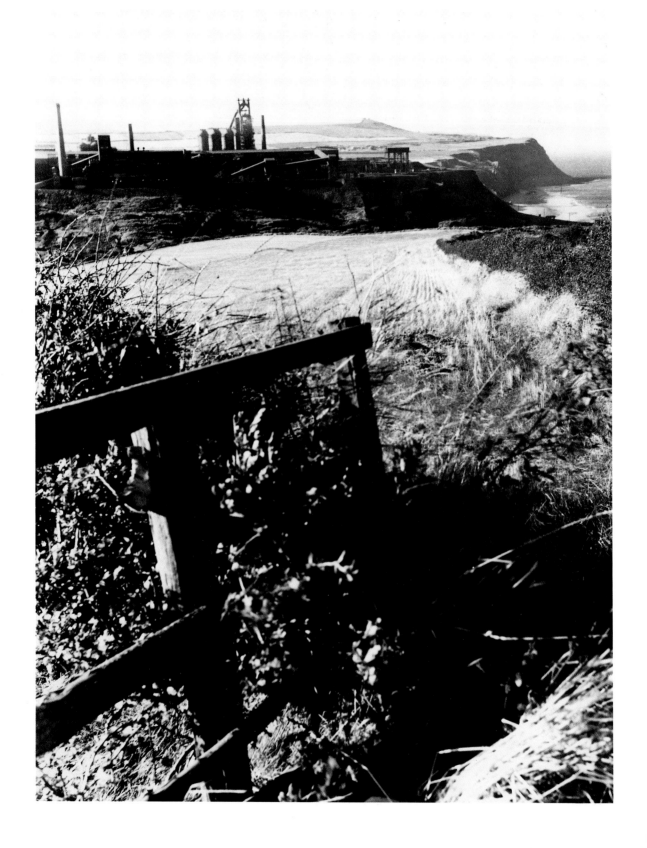

JANE GARDAM

The Iron Coast

Notes from a cold country

Photographs of Yorkshire
by PETER BURTON
and HARLAND WALSHAW

SINCLAIR-STEVENSON

2 *Ironworks, Skinningrove*

Acknowledgements

We should like to thank William Mayne for hours of help and many
suggestions; Neville and Felicity Pearson for details of Skinningrove
and the steel industry; Anthony Wharton for a memorable tea and
discussion above the moat of Skelton Castle; Lady Mary Bell for lunch
at Rounton and reminiscences of her family; Lady Serena James for
making her house and garden so welcoming and showing us many
delights.

 We owe a great debt to Penelope Hoare for befriending the book
from the beginning; to Vera Brice and Leslie Robinson for invaluable
assistance with design, and for the map; and to David Winpenny
for identifying the stained glass in Coatham Church.

First published in Great Britain in 1994
by Sinclair-Stevenson
an imprint of Reed Consumer Books Ltd
Michelin House, 81 Fulham Road, London sw3 6rb
and Auckland, Melbourne, Singapore and Toronto

A CIP catalogue record for this book
is available at the British Library
isbn 1 85619 427 2 (hardback)
isbn 1 85619 514 7 (paperback)

Typeset by Falcon Graphic Art Ltd
Wallington, Surrey
Printed and bound in Hong Kong
Produced by Mandarin Offset

List of Photographs

1	Fishermen's huts, Skinningrove
2	Ironworks, Skinningrove
3	Whitby Abbey
4	View towards Redcar
5	View towards Ravenscar
6	Sandsend
7	Fyling Hall
8–14	Staithes
15	Boulby Mine
16–18	Roxby church
19–20	Boulby Cliffs
21	View of Hunt Cliff from Marske
22–26	Saltburn-by-the-Sea
27–34	Coatham
35–39	Warrenby
40	Teesmouth
41–50	Kirkleatham
51	ICI at Wilton
52	Warrenby
53–56	Teesmouth
57–60	Middlesbrough
61–62	Ormesby Hall
63	Ingleby Arncliffe Hall
64	Roseberry Topping
65–66	Easby
67–74	St Nicholas, Richmond
75	Croft-on-Tees
76	Egton Bridge
77–80	Rounton Grange
81–82	All Saints, Great Ayton
83–84	Guisborough
85–86	Rosedale iron mines
87–88	Wheeldale Moor
89–94	Skelton
95–97	Skinningrove

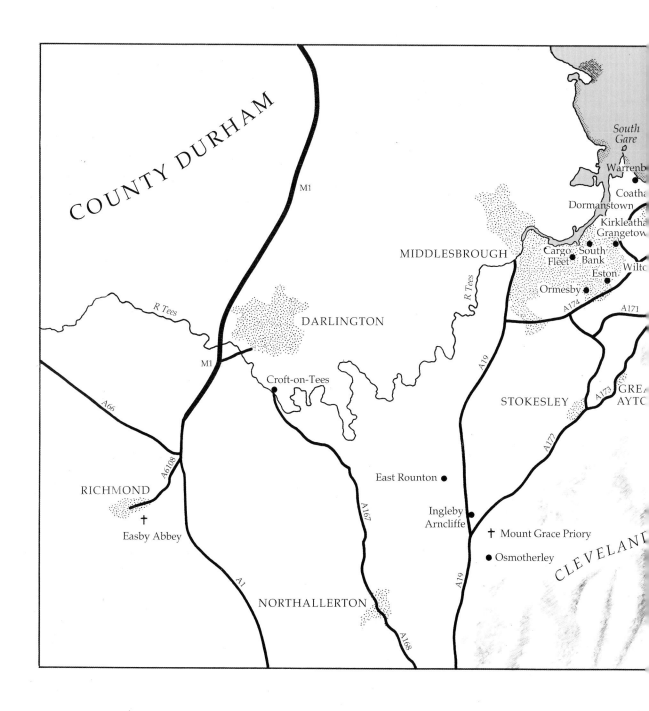

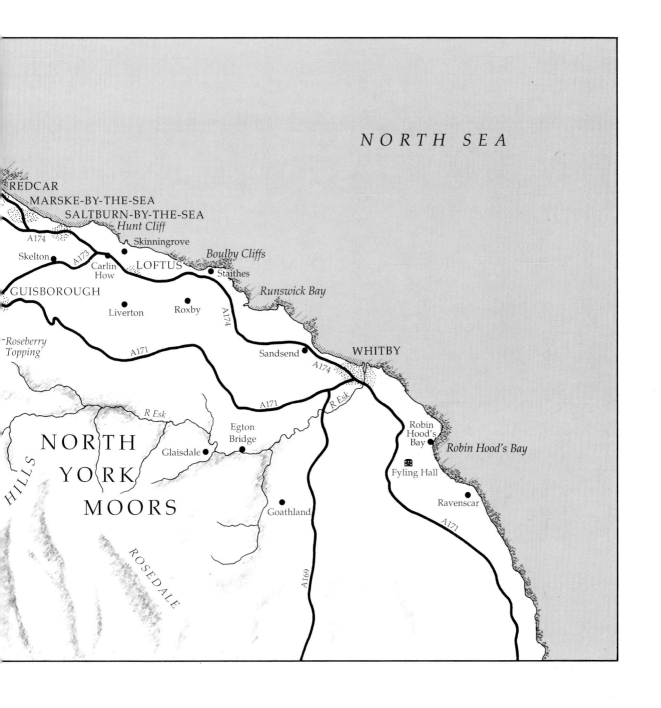

Dedicated to Joan L. Grasby

Preface

I spent the first years of my life in perpetual sunlight beside a noisy, clean and always sparkling sea. To the north, orange and golden clouds ballooned up into the sky. To the south, huge cliffs covered to their edges in silvery grass reared up their heads. Inland, to the west, rippled a line of low hills. It was years before it occurred to me that anyone might prefer another landscape.

I had travelled by this time to Italy and France, bathed off the coasts of Cornwall and Wales, but always I had missed the squirm of delight in the gut that came with my childhood's Iron Coast. Like Plato's 'essential table', Cleveland was my essential coastline.

I was twenty-seven when I heard a woman saying at a London party that she had visited Cleveland for the first time, and I turned – very eager – and asked what she had thought of it. 'Terrible,' she said, 'oh, terrible, terrible. You couldn't call it the seaside. Poor wretched people – terrible. Terrible.'

My part in the exploration of this book has been to try to account for what I remember and still love, and to prove that my memory was not only the elf-light of childhood.

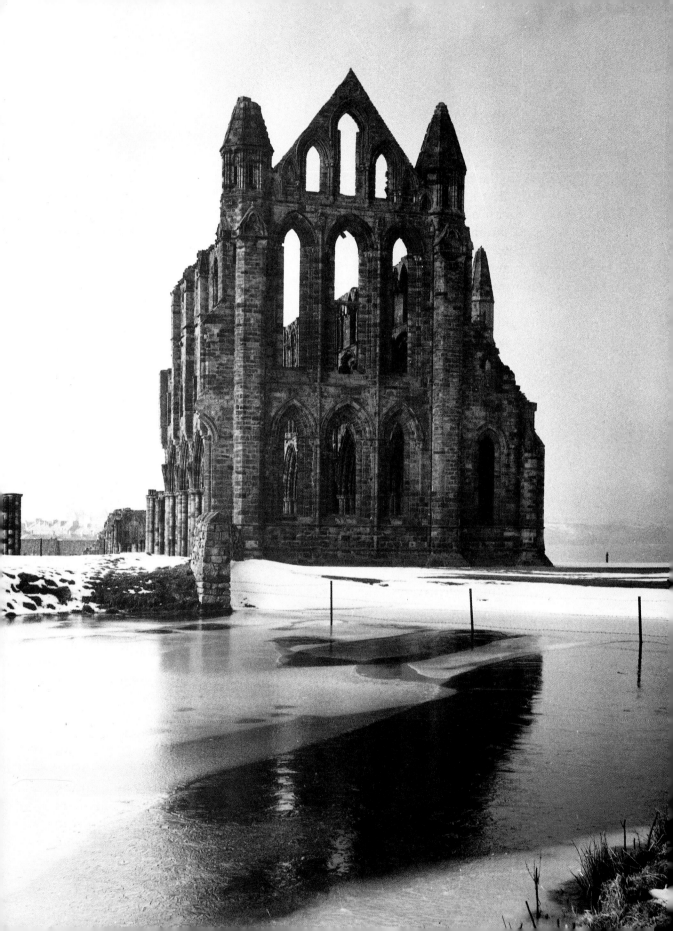

The Iron Coast

A great black tooth, the ruined abbey of St Hilda, stands high on the cliff above Whitby, facing every wind that is flung against it. The Saxon abbey St Hilda founded, and then this towering Norman one, have stood above the Bay of the Watchtower by the side of the Roman signal station for 1,300 years. It is a place so holy that kings and queens chose to be buried there for centuries, and birds have always been said to be afraid to fly over it because Hilda's magnetism causes them to drop dead to the ground.

Hilda was a Northumbrian princess who spent her childhood hiding from her father's enemies in the Kingdom of Elmet to the west. When at last her father was killed, poisoned by a neighbouring king, she became a nun and then the abbess of Hartlepool on the northern bank of the Tees. The wharves where her ships were tied can still be seen embedded in the harbour wall. She was waiting in East Anglia for a boat to take her to join her sister in a French convent, when St Aidan sent her to Whitby. She was given a piece of land to found what became a great centre of the Church, a monastery and convent of monks and nuns over which she ruled. She became a mighty personality. At the Synod of Whitby in 664 the great decision was taken (reluctantly at first by her) to turn the English Church's face towards Rome. She died after seven years of fever praying for a Church at peace. Caedmon, the 'first English poet', was one of her farm labourers on the abbey lands. His lovely *Hymn to Creation* is the 'first written poem'. Hilda had him made a monk. Often on the cliff-top he must have seen the dawn, the sun coming up out of the icy sea like the first day of the world.

Twenty-five miles north of Whitby, on the Yorkshire bank of the mouth of the Tees, spreads the twentieth-century hell's kitchen of one of the great chemical works of the world, with the nineteenth-century graveyard of the steelworks in front of it and the remains of the streets of poor industrial towns tangled in its entrails. Out of the tops of refinery chimneys flames like lurid petals bend in the wind. The wind takes the fumes and smoke across the coastal plain, deep down into lungs, withering up gardens and struggling attempts at trees, and across to Scandinavia which it coats with bitter, orange dust.

In between is a stretch of coast not well known, a plain so low and bare that it is invisible from the sea and a church spire rises from the water like a needle. The coast appears to begin with the long lines of the Cleveland Hills several miles inland and the broken cone of Roseberry Topping, like a midget volcano. Along the hills is one black dot, the memorial to Captain Cook who was born in a cottage on the marshy fields. Salts and ores have been worked between Roseberry and the sea since medieval times and probably since the Romans, but it was the discovery of massive deposits of iron in the hills during the nineteenth century that brought the poor and homeless and workless swarming here from all over England and starving Ireland. Within one generation the estuary began to seethe with people like the mud flats of Bangladesh. Middlesbrough and 'Teesside' were born.

The Iron Coast feels different from anywhere else. There is a hard, quiet unhappiness about it, and the plain and seaboard tend to be avoided rather than explored. The young do their best to get away. Even a century ago Dickens, who was usually ready for anything and a good east-coast man, was too impatient here. He got out of the train at Redcar station, walked down to the promenade with his carpet bag, looked quickly north and south, walked back to the platform and caught the next train on to Scarborough. Yet this small rag of the country has bred international heroes, saints, scientists and geniuses. It has twice raised armies that came within a thread of changing a dynasty and once ordered a clipping and reshaping of the powers of the monarchy that has survived nearly 800 years.

The Iron Coast starts around Whitby, at Robin Hood's Bay, Runswick and Staithes, three picture-postcard places, tumbling down cliffs, rather like Cornwall but with a pale, icy sea. At Robin Hood's Bay and Runswick you sit among ornamental lobster pots in the pocket gardens of the fishing cottages, now holiday places, and look down the chimney of the cottage below. Staithes, a queer place down a steep little canyon, was cut off and unsociable for centuries. 'Staithes folk are different. Everybody there has black eyes', we were always told. It is where the women wore and sometimes still wear the bonnet with a long flap down the back, high-ruched over the crown, which is said to have started out as the Spanish mantilla. An Armada ship is supposed to have come smashing up the creek. There is a big trade in photographs by the great Victorian photographer, Sutcliffe – wild and raucous shrimp-girls dangling about the boats, with their skirts kilted up in the waves and baskets on their heads. Whiskery old salts mend nets. It is less rumbustious now, and cleaner.

The true iron begins ten miles north of all this, below Cowbar Nab on Boulby Cliffs, the massive red-brown warriors that stand, one thrust out east of another like a folded frontier, hard white beaches lying dizzily below. The great view of and from them can now only be seen by birds and helicopters. Barbed wire and warning signs bar the tottering cliff-path that is dropping away. Under the sea the Boulby mine runs out invisibly for more than a mile. There is special danger money paid to Boulby miners.

Whitby slithers into Sandsend where jet was mined. It had been gathered up from where it dropped on the beach from the cliffs above since the Bronze Age. A Bronze Age necklace of nearly 300 pieces was found in a burial mound on the moors. The Romans sent polished pieces of jet home as presents, like seaside peppermint rock, and distributed it about the Roman Empire. In medieval times it was used in church ornaments, but its heyday was when Queen Victoria entered her interminable widowhood and black became the fashion. Nothing is blacker than polished jet. In the 1870s the jet industry along the cliffs and in inland dales of the North York Moors employed 15,000 people at Whitby alone.

Standing back from the Boulby edge, looking towards the mines and the sea, is Roxby's church of St Nicholas with its strange tomb to the Boynton family, standing on vase-shaped marble legs. Sir Thomas Boynton, twenty-two inches of brass, lies nearby, with kindly face.

Round the last Boulby headland is a green crumble of cliff-top and then the less high but still magnificent table-top of Hunt Cliff above the Victorian watering-place,

sweet Saltburn-by-the-Sea. It is one of the highest cliffs in England, and mighty for such a tame and gentle little town. It thrusts out long and rough. A hazard of red boulders at its feet runs out into a long shamble of rocks.

Then the sands begin, sweeping north for over six miles. They are the 'finest in England', white, wide, empty, silken, safe. At low tide they are wet and sculpted in ridges, flashing with salt pools, glittering in places with brush-strokes of shiny black sea-coal. The wind hurtles over them and mile-long snakes of fine stinging white sand blow like smoke just above their surface. On windless days a bluish light reflects in them. They are the sands of *The Walrus and the Carpenter* which Lewis Carroll is said to have written after a day here with friends during a long vacation from Oxford. He lived inland, just south of Darlington, in a great red rectory where there is still a wonderland garden of polished dark trees and blazing roses. In 1932 an ancient man remembered Lewis Carroll lying in the grass of the rectory garden under an acacia tree, writing. The rich and comfortable rectory, now flats, looks much as it did, though eleven brothers and sisters no longer play in it.

> Fair stands the ancient Rectory
> The Rectory of Croft,
> The sun shines bright upon it,
> The breezes whisper soft.
> From all the house and garden
> Its inhabitants come forth,
> And muster in the road without,
> And pace in twos and threes about,
> The children of the North.

It must have looked soft and almost southern when he returned to it from the scoured white shore.

Over a thousand years five small villages grew along the edge of this swooping bay, like seals or mermaids belonging more to the sea than the land. There was not even a road that joined them until the last century. Everything and everyone went along the sands. As late as 1858 William Leyland, a leisurely fellow on a walking tour, sat on the top of Hunt Cliff watching the commerce of the coast – carts and horses and donkeys and little well-ordered groups of people passing and repassing each other across the sands. He found them rather dull. 'Liveliness is not one of their characteristics.'

But this was inaccurate. He should have stopped and talked to them. Hunt Cliff above Saltburn has had its excitements. For several centuries it was the breeding place of a great tribe of seals known for their exceptional intelligence. They established themselves on the rocks at Seal Goit, and had a rota of lookouts. One seal stood sentinel while the others basked and 'when he saw anyone coming he would push down a stone with great noise and throw himself into the water to alarm the rest'. The seals liked the Saltburn women – so much so that Saltburn men would dress as women when they set out seal-hunting. The seals were used to the women scrambling on the rocks en route to find medical attention, carrying babies rather than weapons. The babies were brought to a cave at the foot of the cliff where lived an agreeable Hob who knew a cure for the whooping-cough. The mothers sang a supplicatory song, like Ancient Greeks at the Oracle. The seals listened.

And here, according to Camden in his *Britannia* (1568), are found on this coast:

> yellowish and reddish stones, some crusted over with a brinish substance,
> which by their smell and taste resembled Coperas, Nitre and Brimstone;
> and also great store of *Pyrites*, in colour like brass. Near, at Huntly Nabb
> the shore (which for a long way has lain open) now rises into high rocks;
> and here and there, at the bottom of the rocks, lie great stones of several
> sizes so exactly formed round by nature, that one would think them bullets
> cast by some artist for the great Guns. If you break them you find, within,
> stony serpents wreathed up in circles, but generally without heads.

There is a legend about St Hilda turning all the Cleveland serpents into stone. Between Saltburn and the estuary there was no common meeting place for the people of the coast. The villages were separate communities, all looking out to sea for a livelihood from fish or contraband. There was one church, St Germaine's, at Marske, about halfway along, lonely on a sand dune, its graves all falling over the edge of it. Captain Cook's father was buried here though no one knows where, and there are other extraordinary headstones all honeycombed with wind, one of them commemorating a boat-load of smugglers who were drowned together and put companionably down the same hole.

The memory of Cook the elder survives as a pleasant one. He was a stonemason turned bailiff in Great Ayton, an inland village a few miles west, and illiterate. He came to Marske after the death of most of his family except for the genius son, and learned to read in old age in order to understand the account of his son's voyages. Father Cook died just before the murder on the Polynesian beach.

The nearest similar building to delicate St Germaine's, held together now by donations (there is a new church in the village, near beautiful Marske Hall), was by the river mouth at Warrenby, far along the sands and standing on them. It was a poor place called St Sepulchre's, which is a mongrel name, much younger than St Germaine's and not in Domesday Book. It was probably a mortuary chapel down on the beach for the bodies of washed-up sailors. At the Reformation it was found to be so poor it was hardly worth sacking. It faded away into the sand. A nearby sand dune called Church Hill outlived it by a few hundred years until it in turn disappeared. A learned gentleman, Dr Fallow of Coatham, wrote a monograph about St Sepulchre's in 1866, but then found he had made no discovery after all. When he told the village, everyone had some sort of race-memory of the little church. Fishermen digging for bait had, for hundreds of years, been turning up skulls.

Long before the chapel was built, in the twelfth century, the Coatham and Warrenby dunes and marshes were busy places. The Tees was, oddly, thought to be too dangerous for shipping and Coatham became the big port. There is not a trace of it now but plenty of signs of the even older salt-mines on the marsh that were managed by the Augustinian monks from Guisborough five miles inland. Thousands of men are thought to have been employed among the old ox-bow lakes, the rattling bulrushes and the marsh. All now is turned into a grey little nature reserve. No life stirs except wonderful birds and some rare salt-marsh flowers. The Bloody Cranesbill, usually found on Pennine limestone, here flowers by the sea. It is brought there in the limestone used as flux for the blast furnaces.

Near this was 'the camp of refuge' by the Tees where the Cleveland people made the last stand in England against William the Conqueror, and very nearly killed him. The place had a rampart round it so that it was enclosed entirely by marsh and sea and approached by a causeway. Fighting here, the king lost his bearings when a sea fret came down and was only just rescued from drowning.

The sea fret is still about and can descend at any season. It is an icy, blinding, liquid mist that takes the curl out of your hair and the heart out of your body. Until the 1930s Cleveland people spoke of 'swearing like Billy Norman'. William, three years later, marched on Coatham and destroyed it. He razed every building along the coast and left nobody alive. All was laid bare for generations. About 100,000 people perished, the devastation of the countryside north of York as far as the Tyne was almost total.

> Of all his crimes against humanity the Conqueror is said to have repented
> of the harrying on his death bed. That was no consolation to the British,
> Celts, Romans, Angles, and Danish inhabitants whose genetic lines were
> permanently severed by the extinguishing of all races in the area.[1]

Warrenby rose and fell and came alive again and was erased from the map for a second time in 1992. It had become a poor industrial ramshackle slum, a rat-hole in the marsh, a place unloved for a century, astoundingly different from its medieval prosperity of salt and ore and rabbit-breeding in the warrens. Yet standing about the marsh nearby, astonishingly different from the back-to-back houses that have gone, are the older, stranger houses of the marsh that have outlived them. One, Marsh Farm, a compelling, ominous building, stood in the dunes until 1992 under the scream and steam of the ironworks, built partially from the stones of the vanished chapel of skulls. It was once a smugglers' place, then a farm where there must have been very poor pickings though it was a fine substantial house. There are good stories about it – kegs of rum wrapped up and put in cradles and rocked as sick babies when the customs men called by; and a ring cut from the finger of a dead sailor on the beach, 'but the thief never prospered after'.[2] In the 1850s, one of my ancestors, mighty of beard, lived here and was remembered as a well-rested man who never left his chimney corner. Beside him were his Bible, churchwarden pipe and tobacco pouch. He was said to be a 'very *good* man'. God knows what he did with his life between the ironworks and the sea. His son became a Canon of Winchester.

Behind Marsh Farm the steelworks loom like giants on fire. At their peak the sun used to set spectacularly through their smoke and parties of Victorian gentry would walk on the sands to observe each evening's reliable performance.

Just beyond the heart of the smoke and flames was Middlesbrough, long after Waterloo still a village of forty souls. By the turn of the century it supported (though that is not the word) 91,000 and had become 'Gladstone's darling, youngest child of England's enterprise, the infant Hercules', the fastest-growing town in Europe. A naturalised German, Henry Bolckow, and John Vaughan, a Welshman, founded the first colossal smelting firm here and in 1850 iron ore was discovered in huge quantities in the Cleveland Hills. They were devoted friends and lived next door to each other in Queen's Terrace, Middlesbrough, under the railway bridge. They were followed by the iron-founders

[1] *Ancient Cleveland from the Air*, Richard Crossthwaite, Tees Towing Co. Ltd, Middlesbrough.

[2] My great grandmother's diary.

Bell and Chaloner, Dorman and Long. Soon half the great buildings of the world had Middlesbrough girders. Sydney harbour bridge was 'the great child of Middlesbrough'. Lambeth Bridge in London was built here, and the Soerstrom Bridge in Denmark. There were two revolutionary bridges of Middlesbrough's own. The Transporter that still rises 200 feet above the docks and quays is a huge hanging ferry for vehicles and up to 600 people. It runs to Port Clarence in Durham and back again, every few minutes lifting 600 people like boxes of ants. Near it the Newport Bridge is slung between high towers and could be lifted a hundred feet 'at the touch of a hand' in forty-five seconds.

The steelworkers were grey men. They aged fast. They were never well paid and toiled out their lives in grit and sweat, getting to work in all weathers in old rattle-trap buses or filthy railway coaches, or moving in little shoals along the trunk road through the chimneys on old push-bikes with tea-cans swinging from the handlebars, calling out wry jokes. They were under-educated, poor, intelligent, stoic. Hardly anyone had been far from home. Then the last war scattered them. After it, the new development of the great chemical works of ICI promised riches and security to those who remained, overnight and for ever. But this did not happen.

The first employers of these tens of thousands usually lived at a healthy distance from the Works. Princes and nabobs, their houses were palaces, and private yachts were anchored off Saltburn sands. By the old aristocracy of the Halls and Parks and Castles of Cleveland they were regarded with amazement, unless, like the ancient Chaloners, they joined them. The Chaloners had had a long interest in minerals. In the time of Edward VI, Sir Thomas Chaloner was allowed to see the Pope's alum mines in Puteoli and saw that Puteoli was similar to Cleveland. He smuggled some Italian workmen out of Rome in casks and opened what were probably the first alum mines in England. He was excommunicated.

The nineteenth-century Chaloners were clever too, but generally the new Vulcans found the old Yorkshire families inert and the work-force found both the aristocracy and the iron-founders a different order of beings.

It was the women of Cleveland who held the Works – and everything else – together. In the terraces of blackened back-to-back houses right under the white-hot diamond-bright steel bars caught up in huge pincers, steam whistles shrieking, alarm bells clanging (there were horrible disasters), the women looked after the men. There could be more than twenty boarded in a two-bedroom house, sleeping shifts day and night in the same blankets. The women ruled. They provided, cooked, washed the clothes, kept the peace, threw out the drunks, tended the sick (and sick they were: there was typhus on Teesside until the 1850s), gave birth, worked, and died at home. They earned only shillings rent a week and were scarcely ever able to leave the street. Taken for an occasional outing to picnic in the hills by charitable organisations or the families of the ironmasters, they looked down at the smoke that was home and said, 'Dear God, up here is heaven.'

The ironmasters were not all tyrants. Some were reformers, Quakers wanting to make a New Jerusalem. Some were benevolent despots, some atheistical paternalists like the Bells – rationalists, Fellows of the Royal Society, international scientists. Some knew a few of their workers by name. Lady Bell's classic *At the Works* (1907) is still in print[3] and

[3] Virago Press.

tremendously worth reading. Florence Bell and others like her organised soup kitchens and medical help and the churches roused themselves from eighteenth-century apathy. One ancient local family, the Turners of Kirkleatham, who had been paternalists on their estate for 300 years, turned their faces towards the black chimneys and gave themselves over entirely to serving the Cleveland people. Teresa Newcomen, of this family in the nineteenth century, founded an order of nuns, the first since the Reformation. They were medically trained and connected both to Florence Nightingale and the great Sister Dora of Walsall. As The Sisterhood of the Holy Rood they still keep going in equally daunting and more horrible modern Middlesbrough.

The Catholic Church arrived in force to serve the Irish, and the priests with their collecting bags at the Works' gates on wages night were a sight called scandalous by the Anglicans.

Joseph Pease the Quaker founded a co-operative venture, 'The Owners of the Middles-brough Estate', and then rebuilt the town of Saltburn on a higher, cliff-top level in the pattern set out in the Book of Revelations. It was to be the Celestial City, with streets named after precious stones: Diamond Street, Pearl Street, Ruby Street, Amber Street. They look quite modest today – solid with Victorian gables, and no gardens to speak of, no fountains, no seraphim, but at the time they seemed a metaphor for grace. Their colourful and enamelled bricks were locally made, each house slightly and proudly different from the next.

For years the captains of industry paid for hordes of children to have days at the seaside, and they would arrive on the railway (built by Pease), sometimes 20,000 in a day, from the gloom of Cargo Fleet, South Bank, Grangetown and Warrenby, the trains stacked outside Redcar and Saltburn stations, fizzing with steam, waiting to deposit them: twenty crop-headed adenoidal faces pressed against every carriage window. They were mostly boys. (Where were their sisters?) They exploded, yelling and whooping, on to the excursion platforms and hurtled like a river down to the white sands, where – like Carroll's oysters – they danced. They also swore, picked their noses, fought each other and devoured hunks of bread and jam. They were dressed in some sort of black serge and looked like beetles with albino legs. They scampered barefoot, but back-street children round Middlesbrough were used to being out-of-doors without shoes. They were like merry, under-fed serfs, but full of fight.

There was another plan for the Iron Coast growing alongside the industrial explosion, and it had been discussed off and on for 150 years. Those wonderful sands, that safe and shallow sea, that marvellous air! It is said that Redcar and Saltburn were the first places to have air that was 'invigorating' and 'like wine', and the beautiful contemporary LNER posters, the best by Leonard Cusden in the 1930s, and obtained 'free from the Town Clerk', are fresh and joyful, and collectors' pieces now.

Cleveland people live for ever. Their complexions glow, thanks maybe to the freezing wind, and as early as George IV there had been talk of creating 'the Brighton of the North'; George III had been sent to the cliff-tops above Robin Hood's Bay to an establishment that, it was hoped, would cure him bracingly of his madness.

At last, at the end of the nineteenth century, hotels began to go up along the seven sandy miles. The Coatham stood in majesty on Coatham promenade with turrets and

pinnacles and towers, big as the Cipriani in Venice, built out of beautiful little white lacquered bricks and decorated with superb local ironwork. At Marske a smaller, sharper-edged black block, built first as the mansion of Mr Pease, the railway king, stood out on a windy sandbank called The Stray. At Saltburn were two renowned hotels, one of them, the lovely Alexandra, standing high on the esplanade with twenty-foot-high curving windows and suites of rooms of almost Roman amplitude, the bathrooms with tubs the size of a modern hotel bedroom and brass and marble fittings. Maids in mob caps as late as the 1950s wheeled in your breakfast on trolleys with silver domes above the bacon and eggs and informed you that your view across to Hunt Cliff was 'the finest in Europe'.

The Zetland Hotel at Saltburn, owned and built by Pease, the good millionaire, was long a railway hotel and had its own platform and comfortable railway carriages, from which stepped huge Victorian families on holiday. They were swept inside by bellboys and porters – children, nursemaids, mountains of luggage, parasols, bath-chairs, crinolines, bustles, dogs, elephantine varnished tennis racquets, flimsy bowling-hoops, battledores, baby-carriages with fringes and frills. You can see them all in the photographs round the walls of another – very ancient – Saltburn inn down by the sea, The Ship, as you eat your chips at plastic tables. This inn has a distinguished smuggling past and a long tunnel from the cellars to a pick-up point inland behind a curious conical mound, a Bronze Age burial place, called Cat Nab. The photographs show the stately tourists of a hundred years ago gliding about beside the bandstand in Saltburn's Italian Gardens. Large girls with a lot of hair are running about the gravel paths in long black stockings, blanketed with petticoats.

The spidery ironwork of the Halfpenny Bridge above them is now demolished. Beyond it is the rose-red railway viaduct, still in use by the Mineral Line that loops all about the cliffs between Skinningrove and Teesside, laden with potash. This viaduct was the first bridge in the world to be built with hollow brick pillars.

Above the heads of these easy people the benign hotels awaited them, and out to sea before them stood the pier with its graceful iron spars and little theatre standing at the end. Another flimsier theatre stood nearby on the sands where the Pierrots danced and sang.

The Zetland Hotel in particular was an astonishing place. Pease built it with the intention that all classes should enjoy it equally and pay only what they could afford. In a roof turret decorated with wonderful Dormanstown ironwork he made an observatory from which rich and poor together were to survey the stars.

It didn't work. The new rich had struggled to afford The Zetland and didn't want to be reminded of those who couldn't; and the Cleveland poor have never been noticeably fond of being patronised.

Slowly and then faster the idea of enlightened tourism faded away along the coast. The rich moved out, the old aristocracy continued to live apart and never went on holiday anyway, and Cleveland became a militantly working-class place and took its holidays abroad in packages. Though the hotels had a sort of life in the Second World War when the army knocked spots off them, they are sad sights now. The Zetland struggles on, rather threadbare. The Alexandra has been made into apartments. Pease's haven stands on The Stray like a safe-house for ghouls. And the poor Coatham has died from its turrets down, like a neglected plant. There are boards across its hundred windows. In its roots a brave little club promises Health and Beauty. Dirty chip papers scratch the promenade.

If you walk away from The Coatham down to the sands, along the beach and far along the bay towards the South Gare light and look back, you can see it like a great beached ship through the skeleton of the eighteenth-century fishing village it was meant to replace.

Behind you, if you turn and walk, is the site of the old ironworks of Warrenby, and of Grangetown, now 'the unhealthiest place in the world'. A little belvedere has been built from which to view the mouth of the Tees that can sparkle and flash on sunny days. Poison clouds drift by on dark ones, and flames flap out of the chimneys like slippery yellow hair. From here corncrakes can be heard calling in the abandoned fields.

There was never any real hope for 'the Brighton of the North'. The wind blows full in your face and has touched nothing else since it left the North Pole, and visitors don't stay long enough to know that when the wind drops it is a different world. The light is peculiarly clear. The sea is transparently blue and scattered with crocodile rocks trailing spinach-green weed. It is a safe place for leisurely paddling and only changes its nature a little way out, near Salt Scar and The Flashes, where it is as deceptive as The Goodwins. This is terrifying water smiling in the sun. Captain Cook learned his seamanship along the dangerous lee shore and young men who did this, says the *Encyclopaedia Britannica* (on Cook), 'had little to fear from any other sea'. Redcar had 'the first lifeboat in the world'. It is on show in a wooden house along the prom.

Sometimes on the sands now, far beyond the help of the local lifeboat, there can be found, looking in at the windows of The Coatham, a huge tanker crazily off-course from its convoy which stands in procession on the horizon awaiting the tide for Teesmouth. There was a ship wrecked once, full of Chinese sailors who all had to be boarded out in Redcar lodging houses. They left several memorials of themselves, Yorkshire folk with Chinese eyes. About 1860 there was a little sailing ship that fetched up one night in the middle of the dunes looking down on Coatham High Street, all its ship's furniture in place, all pots on their hooks, not a sign of a crew. Bright as a seagull it stood there on tiptoe for years until it broke up and withered away. Children played on it for a generation. It was called 'the Ship in the Grass'.

There were travellers who loved this coast who were quite uninterested in grand hotels. They returned year after year for inconsequent, charming holidays doing nothing in particular but wandering about taking notes and talking to the natives. One, William Hutton, aged eighty-five, found the Iron Coast for the first time in 1808 and wrote *A Trip to Coatham*. He was enchanted by it, so remote and dignified a place, hardly knowing its neighbouring villages, so sandy and so clean:

> I thought there was something very respectable in the character of the
> lower ranks. I was in many of their mud-walled dwellings, and found them
> clean and orderly as is conducted by the hand of prudence. Their persons
> and manners are in the same style, also those of their children. I do not
> remember seeing a ragged person. It brought to my mind ancient times of
> simplicity before luxury had made inroads and ambition had dazzled us.

He spoke of the seaward-facing houses up to their eaves in the sand which had to be shovelled away each morning, and the windows where only one small pane was made to open. The long high street of Coatham was so pure that

a man may wear white stockings every day of the week. The mountains of sand almost forbid the foot and no carriage above a wheel-barrow ought to venture. If a man wants a perspiring dose he can procure one by travelling down the street and save his half-crown from the doctor.

Mr Hutton noticed the strange cottages, no longer thatched, 'which shows a place emerging into history'. They are still there, some whitewashed, some of wonderful black and gold sandstone with huge rippling pantiles like those in Tuscany, but black. The windows are deep and thick, some round like port-holes and into each low house you step lower still into a long passage running front to back and crackling with sand. A row of modern houses has been built in front of these now. Before them, life in the half-buried little street must have been very like the life of the rabbits in the dunes all round them. Pevsner – and most people – have missed these unique cottages.[4]

The last house in the street is older and different. It is tall, and was once a nunnery haunted by a wailing woman. Excavation in the cellars produced skeletons of a young woman and her baby. Exorcism by the vicar of Coatham was effective, but the building still gives pause for thought. And horror.

Opposite it on the golf-links stands an extraordinary house, yellow, Italianate and called Barker's Farm. Once noble, now sad, its neighbours are a caravan site and a rough-looking holiday camp. The golf-links of the respectable local club merge here into scruffier ones once granted to the Irish workmen in the Warrenby hovels who called themselves 'The Warrenby Artisans'. Accustomed to Hurling they flew about the dunes and the toffs of Redcar held on to their hats. Matches were dangerous, colourful, totally democratic, and very close-run. England and Ireland at one.

Around the back of the rabbit-warren cottages a Victorian terrace turns into a dainty stretch of houses made of little black and white checked brick, like pumpernickel. These lead again into the village of Coatham: Nelson Terrace, Victory Terrace, Trafalgar Terrace most elegant and genteel.

There is a spacious beauty here. A cricket-field that was once the village green has, to the north of it, maybe the oldest building for miles around, The Lobster Inn, tall and looming, with a deep-pitched roof and salty history. Terraces run down each side of the cricket-field. The southern terrace has a turret at either end and a pediment in the middle where Victorian and Edwardian ladies used to sit and watch the cricket from an oriel window. In one of these turret houses lived the Lady of Shallot, a wispy dignified woman whose sole duty in life was to place a fresh carnation each day in a silver, trumpet-shaped vase in her turret sitting-room. She was so delicate she had never opened a door for herself. She lived a long life but became rather strange. Poor soul. What Lancelot was she signalling? He never came.

And there were three highly respectable unmarried sisters just before the First War. They were frighteningly old. They painted their cheeks with perfect vermilion circles, which never caused the comment along the Iron Coast of the shameful *papiers poudrés* of the fast Edwardians. For there was an unspoken knowledge that the sisters were survivors of the Regency.

[4] Almost all these cottages have now sadly been 'improved'.

At the foot of the cricket-field beside the railway line is Red Barns, a pre-Raphaelite house built by Philip Webb and adorned inside by Burne-Jones. It is almost in sight of the Warrenby Works but was the house of the dizzily rich industrialist family of Bells. Hugh Bell had just begun to build it after his marriage in County Durham but came to live in it as a sad young widower with his two-year-old daughter, the astonishing Gertrude. Gertrude became a renowned traveller, a colonial administrator, an Arabist, a high-Tory anti-feminist and extrovert powerhouse. At two she was motherless and she and her father clung to each other in the new house alone. Gertrude grew up to be one of the first women at Oxford and left with the highest marks in the university in her year. She thought religion was bunk, travelled the Empty Quarter on a camel alone except for Bedouin tribesmen (at home she was chaperoned to Saltburn evening parties), wrote huge works about Syria, translated from the Persian, scribbled a million (misspelt) letters, founded the great Museum of Antiquities in Baghdad practically on her own and – with a little help from rulers of empires – the Kingdom of Iraq. Her industrialist father and stepmother refused to let her marry the man she loved because, although patrician, he was only a second son. Her next man – a great time afterwards – was married, a Christian, and had to reject her. She flung herself into international politics and the administration of the Middle East, paced the desert weeping for the children she had never had, contracted cancer still very young and killed herself.

Her stepmother, Lady Bell, had moved in to Red Barns when Gertrude was four, an ugly, clever, nice woman, a linguist and playwright who belonged to the literary coteries of both London and Paris. As a child she had sat on Dickens's knee. She did much to extend Gertrude's horizons beyond the Iron Coast but was perfectly happy there herself. Eccentric, absent-minded, badly dressed, formidably well-educated, unselfconscious and with 'no side to her', she was adored in the village as a good and 'definite' woman. Her son born at atheistical Red Barns – they were all noisy free-thinkers – became a saintly missionary in South Africa, died young and broke his mother's heart. He had loved his childhood home, was always drifting back there, sitting for hours in the rabbity cottages talking and listening to tales. Gertrude as a child used to tear about the wide sands on a donkey (rehearsing for the Empty Quarter?) and taught herself Greek in her pleasant bedroom looking at the tree-lined railway and the hills. Below her a model railway had been installed by her father, exactly as Lewis Carroll's had done for him. It steamed about the glades of the garden and ran into its own little glasshouse station, now a conservatory.

In the 1960s this fine house, Red Barns, became a rooming house for down-and-outs, after many years as a boarding house of Sir William Turner's School. The rooming house survives, run by Arabs (though not Bedouin) and Gertrude's bedroom sports the manager's magnificent jacuzzi.

The Bells would have laughed (or wept), for Hugh Bell was an emotional man who liked jokes and nonsense. Gertrude might have wept more. Once, as the house was being built, Hugh ran with his children, one under each arm, no hands, up a ladder to the roof. Shrieks from below. Had he slipped – farewell Gertrude. No Iraq.

Near Red Barns, the church of Christ Church, Coatham, was built by Teresa Turner Newcomen at the height of the Anglo-Catholic Movement in 1848. She was practically

the last of the Turner family after 300 years. In old age she joined her own order of nuns, lived almost entirely at the Hall and in the spirit, and wore a curious medieval black cloak and hood to the end of her life.

She was formidably rich and no money was spared and the church, outwardly restrained and very pleasing, is dazzling inside with stained glass by William Wailes of Newcastle. Purple camels, fuchsia-pink saints, orange and yellow and roseate angels and prophets splash the aisles with fruit-drop hues when the sun shines. Even by candle-light they glow. By the 1930s the windows were abhorred and there were diocesan plans to remove them. In the Second World War they came loose when the bombs fell on the steelworks and people said that it was an ill wind . . . Fortunately a champion, an eccentric woman painter, used to creep in as soon as the All Clear sounded and tighten the windows up again with a screwdriver. They are now listed.

The painter Eleanor Bulmer, my aunt, next painted twelve apostles in the niches behind the altar in rich shades of mahogany. These sadly have not survived as a dastardly priest had them washed away in favour of twelve candy-floss angels. These, too, have all flaked off. Teresa Newcomen saw none of them. She died in the shadow of the Cross only. Now there is plain cream paint in the niches and in the gilded and crimson sedilia.

The Coatham spire is the one that seems to pierce the sea like a needle. It holds a forbidding bell. In Cardinal Newman tradition the church became known 'for the length of its solemn services'. Even the marriage bell in the spire rings out funereal tones, or at least it did at my wedding.

Teresa Turner Newcomen lived inland a mile and a half over fields once under the sea, past Ramshaw's Farm with its rookery and along a lane lined with hawthorns that looked as old as Billy Norman. There is little sign of any of the old civilisation now. All is under pink anonymous housing estates – until you reach the gates of the Turners' village of Kirkleatham.

Kirkleatham is a jewel.

Between its architectural glory and the poverty of Warrenby, less than two miles off, is a whole civilisation, though between its establishment as a pre-Conquest settlement given by William to the family of Robert the Bruce, and its renaissance under the enlightened Herefordshire Turners, there are 600 years.

In Domesday Book, Kirkleatham was a tiny hamlet 'with one free man and seven small-holders with one plough, a priest and a church with six acres, all worth ten shillings'. After the destruction brought about by William's anger over the sea fret it was worth five shillings and fourpence. In medieval times it passed through the hands of several great families before, in 1623, being unexpectedly inherited by the Turners, rich wool merchants on the Welsh marches.

They arrived in 1623 with dark, foreign faces, Celtic and grave, and moved in among the Yorkshiremen and took the place to their hearts, buying more land around the village, building a Hall and settling down contentedly for the next 200 years. The first, Sir William Turner, was Lord Mayor of London but always treated tiny distant Kirkleatham as his home. He looked to its poor and built a hospital for them with chapel and school for widows and orphans. This was added to by later Turners, a New Hall built, at vast

expense. The drawings for the hospital are by James Gibbs. Later work in the village is by John Carr of York. There are suggestions that Christopher Wren was at least consulted.

The first sight of Kirkleatham now is like seeing a midget Venice in a sea of asphalt with green hills behind. Closer, it is even better. The precise and graceful hospital is constructed round a square, the lovely chapel facing you across a courtyard through a rich wrought-ironwork screen and sweeping black and gold gates. The old people, ten men and ten women, lived down either side of it (still do) in little, beautifully proportioned houses, and on either side of the chapel, in two short wings, lived until 1940 ten orphan girls and ten orphan boys, the boys in blue coats with brass buttons, the girls in yellow petticoats with bright green aprons.

In the eighteenth century another Turner (a dandy with peruke and enormous muff) set about making the village into his own private park, uprooting the estate workers and redistributing them about the neighbourhood. It wasn't as disgraceful as it sounds. He provided new dry houses, stores, workshops and a pub on the Guisborough road called The Turner Arms to replace 'the blackguard ale-houses and wretched hovels' and put the accommodation where the work was. He built new farmhouses suitable to the vicinity of the Hall, upgrading one of them to a small but self-respecting castle. He encouraged tenants to experiment with crops and the rearing of pigs and cattle. He found work for the schoolchildren as apprentices and in service, and built the New Hall with glorious plaster-work. The Hall, the very heart of the village, was destroyed in 1953. He also founded a museum in what had been his Free School with a lending library of 3,000 books for everyone on the estate.

When the Turner heir, a nice sweet boy, died (probably of cholera) on the Grand Tour in 1739, the distraught family built a private mausoleum to his memory on the corner of the church. The church itself was rebuilt, apart from the tower, the almshouses embellished with screen, cantilevered roof, a huge Baroque chandelier of gilded limewood and two magnificent painted glass windows (Venetian) showing John, the first Cleveland Turner, and the great Sir William staring wisely down at the congregation. The chapel was filled with treasures. Its theme was based on St Martin-in-the-Fields. In the courtyard was set a tender and graceful statue of Justice, by the London sculptor Andrew Carpenter. It is a most lovely place.

Kirkleatham Chapel became known as 'a wonderful creation', 'the finest almshouse architecture in the country', and the octagonal mausoleum 'the finest private mausoleum'. It is based on the top of the campanile of San Biagio at Montepulciano in Tuscany (1530). Its eighteenth-century windows are still flooded with light; its sad, double life-sized marble figures (by Peter Scheemakers, the leading sculptor of the day, Sir Henry Cheere and Robert Westmacott the Younger) lean gently on urns, staring way over our heads. Vast angels weep over caskets and below the black and white marble floor the Turners lie in ranks. Lichens and flowers and sometimes a small sapling have been known to find their way out of the cracks in the plaster of the walls, and roots to dangle down from things growing out of its Palladian roof; but the tombs have remained unharmed and perfect even though it was once a pleasant echoey place for children to play. I played here when German aeroplanes were dropping their bombs in 1940.

All is now very well looked after privately by the County though not with the Turner largesse. The Turners were never in any trouble for money. Sir William's account books

in the museum show that at the end of every satisfying bottom line he has written 'Deo Gratias'. Two Turner gifts have not survived – the Free School he founded moved away and became a grammar school and then a public school and after that dwindled; and most of the treasures of the hospital and library were sold by idiots to America after the War. A wonderful Gothic dovecote, the only one of its kind in the world and built like a castle with crenellations and spiral stairs, was bulldozed by a farmer in the 1960s. A Gothic pavilion Temple in the Hall grounds with ornate plasterwork inside was demolished in the 1950s. But what is left is still a miracle. The Old Hall or Free School (after a campaign) was spared, the village, the church, the mausoleum, the wonderful hospital stand together on their island, a perfect entity. New main roads twine round them and the chemical works stare down from a mile away, but Kirkleatham is still there.

Half a mile west, below the Eston Hills, is a side turning that leads to Wilton village with its small, over-restored church and two weather-smoothed figures lying in the porch. These are Bulmers of Wilton Castle at the time of Edward I. Later Bulmers helped organise the Pilgrimage of Grace against Henry VIII and one was hanged, drawn and quartered at Smithfield and his wife Margaret burned at the stake, a terrible death even for those days.

Through some trees is the park where the Castle stood, now a nineteenth-century mansion made into offices for the Imperial Chemical Industry. Up through the woods, behind and over a gate, are wider woods on the slopes of the hills with traces running through them of the little railway that the nineteenth-century miners built to carry their ironstone down to Middlesbrough. The mines were all around Guisborough which stands beyond the woods on a green plateau, dominated by the Priory. All that is left is the gatehouse and the broken majesty of a tremendous hundred-foot-high eastern arch that stands as a folly, tidied up in the last century, and used as a backdrop for local functions. There are old picture postcards of polite garden parties – teacups and huge hats and the Guisborough town band. In the parish church is the Brus tomb which was removed from the Priory: merry armoured figures with grins and mustachios and the Cockerell rooster – the Prior's emblem. Guisborough Priory was burnt down in 1289 when a plumber left some hot iron pans in the roof beams. The Augustinians of Guisborough were probably not pleased with him. It was rebuilt, glorious as York Minster, then destroyed a second time by Henry VIII. The monks were enormously powerful and, like the Turners after them, inclined to move the local population about, brothers often having to serve out their lives elsewhere. Those down in the Coatham salt-works (maybe the plumber?) or breeding rabbits in wet Warrenby must have hoped they were serving out some of their purgatory on earth, wishing for Guisborough's famous hospitium in which to rest and die.

Or maybe they wished for a transfer to the next hospitium westward, St Nicholas, above Easby Abbey.

Easby Abbey, on the rim of the coastal plain, below Richmond Hill, is a gentle ruin now, standing beside the older parish church of St Agatha of Sicily. In the church are thirteenth-century frescoes. They almost fill the chancel and climb about inside the deep window niches – local medieval people going about their daily lives in Spring (sowing) and

Winter (delving). Summer and Autumn have been washed away. A gentleman on horse-back looks proudly about, and across to a wonderful Nativity and Epiphany and scenes from the Passion. The faces are all clearly portraits. There is not a hint of Byzantium. The shepherds' legs are skinny and the Magi's legs are strong. The Nativity is tender, the Christ-child swaddled and cross-gartered like a papoose and floating, perspectiveless, high in the air, with two kind-faced oxen licking up the hay round him. St Joseph leans exhausted and thoughtful at the bed's foot – or the stable door – and a bewildered exalted Virgin with a village face bares an enormous breast to the world for its nurture. She is reclining in yards of pale flowing clothes and holding up a flower in her hand.

There are tantalising scribbles behind her – some card-sharp faces and a hoof. In the Passion someone is drawing a long brutal nail from Christ's foot.

Across the church again is the Fall of Man, Eve being lifted out of Adam's side like a rag doll. They have a merry time in Eden, she with a very twentieth-century hair-do, he with a silky, curly beard. The Angel of Vengeance blunders about the sky with a sword, its broad blade ending in rubbery flame. Where he turns to instructing the fallen pair in sewing and sowing and general self-help, they all look rather cheerful again.

The colours are lovely. The three sedilia near the altar have painted and gilded backs, no doubt with portraits of their occupants, three interesting men, the middle one possibly a king with amused hazel eyes and a pleasant mouth. A man we know.

The nave has the remains of great free zigzag patterns of crimson and black on all the pillars, 600 years old. Everything has been recently very well restored and not over-restored. You can wander about the church unguided and even touch the frescoes with your fingers, if you must.

The softened ruins of Easby Abbey in the fields rise high above the church. They are pale-and-dark gold stone, and looking down at them from the west is what appears to be a country gentleman's small estate, which it has been, among other things, off and on since it was the abbey's hospitium, or guest-house, 600 years ago. For several centuries before and after the Dissolution the history of the place was vague, but it lives and breathes very easily – and almost invisibly – now. You can pass the gates of St Nicholas on Richmond Hill scarcely seeing either them or the handmade notice pinned to the wall saying (always!) 'Gardens Open Today'.

Yet this place is famous. Gardeners all over the country ask you, 'Do you know St Nicholas?' and it is a test question.

This is a small estate of country house, timbered park and seven acres. There is a square gravel forecourt – main gates gone – and a high-clipped yew hedge with balls and pyramids and slits through which you see over the park to the abbey ruins, the Vale of Mowbray and the Hambleton Hills. There is a blue haze towards the sea eastwards, and at night a red glow that is Teesside. Sometimes there is also a stink, the 'Tees Reek'. Behind you a quiet stone house sits watching you across a raised terrace of Swaledale flagstones, up eight shallow steps.

It is no architectural classic, like Kirkleatham. It has been greatly knocked about and the only hint of its ecclesiastical past is the bell hanging under the Gothic portico which is supposed to be the one that reminded the monks of the passing of the hours – a bell now full of cobwebs and lacking a tongue. All that is left of even the Tudor St Nicholas are

some shadows of Elizabethan windows in the stone. Nineteenth-century sash windows, and even Noel Cowardish French windows, open on to the Romeo and Juliet balcony (by nineteenth-century Bonomi on a good day) and the Tudor chimney-pots have been replaced by later Victorian tin cans.

Yet from this house there breathes a wonderful sense of continuity and content – and out of it as you stand there usually comes its owner, Serena James, deep into her nineties. She looks you over, welcomes you, tells you to go wherever you like and take any cuttings you want. You ask her if she is a saint, and she says, 'No, but my husband always used to say, "If you have a good plant you should spread it around." ' Then afterwards, she says, you must come in to tea.

Between 1920 and 1960 little St Nicholas became world-famous. Sir Robert James belonged to one of the rich nineteenth-century families who had backed the great Botanical Expeditions to China and Nepal and brought back azaleas and rhododendrons scarcely known in England and impossible to grow in the Yorkshire Dales. Robert James therefore removed a large part of a peat moor that was available to him across the Vale of Mowbray and built a high wall behind a bank of it, on a western face of his garden, as shelter from the icy winters and long cold springs. An army of gardeners (wages five shillings a week) was employed on the rhododendrons, full time. The gardeners ran with asbestos sheeting when frosty, and ran again to remove it when the sun came out. The impossible garden was completely successful and became a wonder.

He then replanned the remaining seven acres with three orchards and a series of open and secret gardens, one leading from another. He underplanted the rhododendrons with rare orchids and trilliums that spread across to an apple orchard where so many columbines still blow in the grass that they are like the grass themselves. He made a bee-garden with two rows of blue hives standing along a double iris-walk between fruit trees, a gooseberry hedge behind, and an acre of trees planted thick with narcissi beyond. He made a cottage garden from rare plants he was given by local cottage gardeners and – his great spectacular – created an immensely long and wide double herbaceous border either side of a broad green walk. It overflows with roses, delphinia, tree-peonies, lilies that lead to a sixteen-foot-long William IV garden seat painted sky blue. These borders make Glyndebourne's seem suburban.

He planted for scent – sweet-peas found in Burgundy that make you feel you have never smelled sweet-peas before, and roses with the same names but deeply different from their descendants – and old roses, roses like forest trees, prickly rugosa, striped roses, French roses. He crammed extraordinary things together, even in the holy vineries, that should by rights have died. The delicate dessert grapes hung in golden bunches above hospitalised fig trees. He said he had no idea why things grew for him – he was an amateur. He hated scientific or 'cheque-book' gardening and said everything he had had been given. He seldom watered or cut the grass and then only with a scythe. He insisted you should enjoy yourself in a garden and please yourself not your friends. He died with obituaries in the learned journals to one of the great gardeners of the age, visited by botanists the world over and with roses and lilies named after him. There is a sensational Bobby James rose that sweeps across a whole bay of the house.

He was dictatorial. He hated yellow in England. He adored blue and planted it in drifts to echo the blue of the hills. Kew and other Botanical Gardens wooed him and

the house still has shelves of numbered seed packages they used to write for when they ran out, says his widow. 'But all is different now, of course.'

It is. Alas. Immemorial, St Nicholas is not. The grass and the tall hedges are sprucely trimmed, but the rest is a semi-wild garden, no less beautiful for that. The apple trees planted for blossom rather than fruit now produce neither. The gazebos are lost behind sleeping-beauty branches. The cottage garden is overcome by weeds and grasses, with the odd astounding lily sticking up through a hole in an abandoned bucket. Potting sheds hold shelves of wonderful flowerpots awaiting tenants. In a puddle – once a pond – are three dark rose-coloured water-lilies with hardly room to float. The two great borders are quarter full of the dead and half full of the dying. Huge Nepalese brooms, thirsting magnolias and roses are tinder black. The immigrant cuttings of the rhododendron garden are now gawky trees straining out of the remains of the peat, so dry that their leaves have twirled up into coffee-coloured cigars and fallen in heaps. There is an occasional trillium, but you have to search. Only the incredible forty-foot beech arch, majestic as Guisborough Priory, piercingly green in spring and golden in autumn, grows better and better. It looms over the old tennis garden which is now green and silent.

We sit at tea in a dining-room with dark purple panelling. ('My husband believed in dark dining-rooms. They show off the ladies' shoulders.') There are home-made cakes, cucumber sandwiches and a motley collection of random guests – a few workmen, a young botanist from York University, four serious people all with double-barrelled names who pay 25p for tea and Bridge each week for the NSPCC. ('Just think if all these people didn't come I'd have to put the place under dust-sheets.') And us. There is the noise of children somewhere. Two stout ladies in overalls are in the kitchen.

She likes a full house. In the War it was packed with evacuees. ('Only one ever came back to see me. I was disappointed.') She urges us to come again and again, and, as we leave, points out at least twice more the Bobby James rose.

It's hard to go. You slink round all the gardens again and see nobody except maybe another worshipper disappearing round the angle of the yew hedges, towards the ha-ha, with the great view over the timbered park to the hills, past the broken greenhouses stuffed with vines. Occasionally Lady Serena passes by – she has already forgotten you – with a great-grandchild pattering behind, carrying a watering-can to the distant, fainting strawberries.

There are plans for St Nicholas in the future but you dare not ask what. A leisure centre? A garden centre? God forbid. In a sense the garden has never had more poetry in it than it has now, a gentle hand just managing to keep the wilderness at bay. This is the last scene of the last act of a charmed world, as distant as Kirkleatham's marble mausoleum.

Below Easby, a threadwork of roads runs back to the sea across the plain through Catterick, the Roman garrison town that has had soldiers in it ever since, which probably accounts for the town's odd rootlessness. Nobody was ever stationed there for long. Beyond it, the Roman stretch of road off the A1 turns into a huge new road widened in the 1950s, with a line of weeping pears beside it, and running eastward past the Carthusian monastery of Mount Grace.

Mount Grace was once so secret in its valley that even Camden doesn't seem to have

known it. It lies deep in the buttercup fields at the foot of Ingleby Arncliffe's hanging woods. Its Priory church tower, tall and delicate from a distance, is only a shell as you draw near.

Mount Grace is one of only nine Carthusian monasteries in England and was founded by a half-brother of Richard II. Carthusians were a silent order and lived and died in solitude except for their worship in the Priory church. There were fifteen cells here round three sides of a cloister court where lived fifteen monks, each in a small two-storeyed house with water-closet, garden and ladder to upper-storey bedroom. In the wall was a V-shaped hatch designed so that the monk could not see who brought him his food. When he died he was buried in an unmarked grave under the turf of the cloister in the same black robe he had lived in all his monastic life. In 1993, however, the traces of a still for the making of liqueur (Cointreau?) were found, so maybe things here were not too bad. At the corner of the great cloister is a large flourishing shrub said to be unidentified. Like the Glastonbury Thorn, it grows nowhere else. Pilgrims taking a snippet are never successful, but are allowed to try.

In 1420 Mount Grace was enlarged to house twenty monks, but all is fragmentary ruin now except for one cell that has been restored to look collegiate and delightful. There is a seventeenth-century house with battlements beside the gates, converted for Thomas Lascelles from the Prior guesthouse. From its mullions and by moonlight the ruins beneath the deep woods, the old fish-ponds and a wishing well, the medieval shrine to the Virgin up in the woods, are silver and black. Very still. By daylight there is a ticket-office and literature of the National Trust, yet there are never many people about. Often you can wander quite alone.

Another ruin almost never visited is across the Vale of York, up the Teesside motorway to the north-west. If lovely Mount Grace is a memorial to an ecclesiastical ancient past, Rounton Grange, beside Rounton village, and standing in its weeds, is a modern, secular memorial to the industrial glory of only a few years ago.

Rounton, the overpowering house the Bells built as their castle, is a distressing place. What there is of it stands in rich green countryside, fields full of sheep and creamy Simmenthal cows, and near to gracious old surviving manor houses such as Ingleby Arncliffe which stand about the plain untouched. Rounton was built with a long drive and fine gatehouses (still lived in) by Philip Webb who had worked for the Bells at Mount Grace: then all is tangle and furrow and you have to turn back and find your way down the main road to the village to the battered Webb stable block and coach houses and rows of red and black apartments over garages, for chauffeurs' accommodation, and a terrace for outdoor servants. There is an air of William Morris here, especially if some of the present-day Bell family are about, painting and creosoting and restoring barns or sculpting, painting and hanging their work in a gallery which was once the stables. Their own sculptures, spectral ten-foot-high chairs for giants, stand in the grass.

Behind this most affable jeans-clad family at work runs a muddy lane which passes under trees to where the great house once stood – a few lumps of masonry grown over by couch grasses now. The site seems unbelievably small for a mansion.

The lane continues past another abandoned red-brick house stuck here and there with William de Morgan tiles nobody has got round to removing. Another little terrace

of old servants' quarters and then the high red wall of a colossal fruit garden. If you struggle through broken gates and prickles and elder bushes there is along the immense wall the dropping skeleton of one of the longest glasshouses in England. Someone has begun to try to grow an apple or two here again, and to clear a patch of wilderness for cabbages. Pheasants run about like chickens among the roses all gone wild. Otherwise there is heavy silence.

The lane leads to another sorrowful place. A tight tall wood once a spinney crowds right down to the banks of some black water, the 'lake' of the destroyed house and Gertrude Bell's 'water garden'. There are still a few clumps of exotic flowers hanging over the oily water. Gertrude Bell's other famous garden, the rock garden full of rare plants she brought from the Middle East, seems to have disappeared.

Rounton Grange, the setting for magnificent late-nineteenth-century county balls and political and intellectual acrobatics, and the place where Gertrude and her lover slept dismally apart, and where Gertrude's ghost (or something strange) once hung above his head in the night though she was not yet dead, became soon after her death in 1928 an embarrassment of emptiness. Prisoners of the Second World War knocked it almost to pieces and in the 1950s Hugh Bell's grandson, left with thirty bedrooms, decided to pull it down. What became of the pre-Raphaelite interiors is not clear, but they have left no sweet savour. The architecture that remains, rose-red, oak-beamed, stalwart and unsentimentally English, is confident and fine but somehow does not inspire. There is a queer desperation about Rounton.

Which makes another almost unvisited Cleveland curiosity all the more remarkable. About twenty miles away, at the foot of the Cleveland Hills, but with no breadth of woods or pale gold cows or old fruit gardens, is Middlesbrough. The landscape around looks quite suddenly as if it has been built up painfully out of cheap concrete, steel and tarmac after a napalm raid. The change is immediate. The light changes. The sulphur cloud appears. 'The Reek' catches the lungs. On the long grey roads all round about people, wrapped up against the wind like plastic parcels, stand waiting at vandalised bus stops for buses that seem never to come, coughing into scarves. A mile or so away is dreadful Grangetown.

A few moments away from these bleak roads and from the hard heart of Middlesbrough and the decaying coal-ports of Teesmouth is the village of Ormesby. Its grand eighteenth-century hall stands far back through great gates and parkland, and people crowd through them all day long. The Pennyman family who built it have left it to the National Trust. The last Mrs Pennyman, who died in the 1980s, used it to the hilt, packing it with actors and artists and musicians and 'functions', and kept it probably more lively than it had ever been.

Almost invisible, to one side of the Hall, directly on the main road with heavy traffic swirling along, is a narrow lane overhung by tall old trees leading into shadow and a narrow wooden bridge to the fourteenth-century church and quiet green graveyard. On this side of the bridge standing back and rather apart is a white rectory, tall trees behind it. The stream looping round it flows deep and fast behind the house along a steep wooded bank.

Ormesby Rectory is now the offices of a food company with computers thick in dining-room, study, sitting-rooms and bedrooms. The company enjoys the house and

has produced a leaflet about its history. You are taken to see the eighteenth-century staircase and door-furniture, the windows and porch and 'underground passage' to the church (but maybe it is a drain?) and the back wall of the oldest part of the rectory, which is 'a thousand years old'. For all the clatter of food advertising and the lines of motor cars on the asphalt that has covered the sweep of the garden round the house, there is a cheerful and contented air about Ormesby Rectory.

And well there might be. From 1635 it was the home of an entertaining old priest called William Lawson of Ormesby, one of only two parishes in Teesmouth. He wrote a book, unearthed and republished only in 1983, and the first book yet found written on gardening for women.

The New Orchard and Garden is about his own Ormesby garden which he used to instruct his parishioners, particularly girls who wanted to be good house-wyves. This meant good cooks, apothecaries, herbalists, wine-makers and bee-mistresses, gardeners and planters. He writes for rich and poor girls, those who can and those who can't afford gardeners and still-room maids. He tries to encourage in rich and poor the idea that the garden shall not be all work, that they shall make green banks and seats of camomile and gilly-flowers and thyme. For ambitious girls he gives instructions for mazes and parterres. He is savage about predators and describes horrible measures against deer and rabbits and birds – though he suggests the importation of a family or two of nightingales for pleasure.

At the end of the book he becomes quite wild with rapture for the idea of the garden – 'What was Paradise but a garden?' – and discusses extraordinary embellishments:

> mounts of stone or wood, stairs of precious workmanship and in some
> corner (or more) a time Dial or Clock and some Antick banks; and
> especially Silver-sounding Musick, mixt instruments and Voices gracing
> all the rest.

He tells his young women:

> You will leave behind you to heirs or successors (for God will make
> heirs) such a work that many ages after your death shall record your
> love . . . To what length of time your work will last.

It is not possible to get much of a picture of Lawson's Paradise now, and the Silver-sounding Musick and Voices feel very far away. There is an old high wall to the south of the house dividing the rectory garden from the gardens of the modern houses beyond and probably built over it. But there is something uncommon about the streams that enclose the rectory on its knoll. Their banks are still flowery with violets and wild plants and shaded by trees from the cold north winds that the rector so complained of and from the chemical desolation he could never have imagined.

The road passes through Great Ayton on its way back to Guisborough. Captain Cook was born a few miles away at Marton and came to Ayton when he was eight years old and his father became bailiff to the lord of the manor. Until the 1930s the Cooks' cottage stood in the village as it had always done, but was then taken down, brick by brick, and put up again in Melbourne, Australia. His school is undisturbed in Ayton – desk, chair, fireplace, hat-peg – and the river still runs by outside. Cook is said to have 'worked out

thousands of sums' in the upper room of this village school 'and never to have got one wrong'. His mother's grave and the grave of five of her children is in the beautiful church-yard of the twelfth-century All Saints Church. So is the grave of 'good Mr Skottowe' who paid for Cook's education because he was a likely lad. Cook left for Staithes and the mantillas of the Armada when he was thirteen, to be a draper. He ran away to Whitby soon afterwards. Then it was the sea for ever.

After Guisborough, again the road goes on, straight to the sea via Skelton, a nondescript small town down either side of a main road with a big, nineteenth-century church at the far end of it made from gloomy sandstone when the town suddenly boomed after the discovery of yet another rich ironstone deposit. This serious Victorian Gothic church is remarkable for a west window in which Christ is depicted seated on horseback and carrying a bow and arrow. Otherwise Skelton is a deadly little place – all ice-cream eaters and scruffy supermarkets and people on the street dismally watching the traffic go by.

But there is a great surprise.

At the western end of the town is an unmade-up lane a few hundred yards long, pretty wide, with several small estate houses along one side of it. Then, across the lane, are two wide metal gates and a drive that floats over park-like fields to a long grey castle, moated and in a fold of the hillside. This is Skelton Castle, built by the Normans, country seat of the family (the original Yorkshire branch) of Robert the Bruce. It is the place where all the barons of England met for the committee stage of Magna Carta before Runnymede. In 1216 King John – in a Billy Norman-like resentment – knocked the castle down, but it was rebuilt and became a place of great power under the families of Thweng, Fauconer, Neville and Conyers, 'and from this little nook of the Cleveland Hills sprang mighty monarchs, queens, high chancellors, archbishops, earls, barons, ambassadors, knights and above all the brilliant and immortal name of Robert Bruce'.

In the thirteenth century Peter de Brus was so delighted with the castle's beauty and especially its chapel that he gave land to Henry Percy on condition that on every Christmas Day Percy would let him 'com to that castell and lead his wife from her chamber to the chapelle'. A faery form of tenure. It has something of *Gawain and the Green Knight*, formal yet frivolous, merry yet strange. What can have been the truth?

Later tenants were stranger still. The last Lord Conyers had no sons and left the castle jointly to his three daughters and they moved into a wing each. Their three husbands began to quarrel and each pulled down his accommodation for fear the other two might grab it. What the daughters did is not related – nor where the sorry sextet went next.

But later, the castle rose again. In the eighteenth century it became the home of Laurence Sterne's friend John Hall Stevenson, the 'Eugenius' of *Tristram Shandy*, a popular eccentric fellow who wouldn't get out of bed when the wind was in the east. Someone once tried to bribe a lad to fasten the weather-cock permanently west to bring Eugenius down to dinner. To no avail. Sterne stayed here often and wrote some of *Tristram Shandy* in the library. There is a little hill called Mount Shandy nearby.

Skelton Castle was described in 1794 as one of the 'grandest buildings ever seen', but a hundred years later tastes had changed and it was 'a large, embattled building of tolerable architecture'. There is now no sign of its emblazoned past. A hundred upper

windows are blank with drawn blinds. The tremendous moat is carefully mown, the great lawns like green lakes. On the mound of the ancient warring families there is a building gothicised by the despised Bonomi who built St Peter's Church at Redcar, the highest upturned elephant in Christendom. Not a trace of the original castle remains. In the village there are people today who have never seen the castle, don't know that it exists, and the owner Anthony Wharton says he wants to keep it like that. He concerns himself with his crops and farms and lives unspectacularly in the shades of his great forebears.

But beside the main gates of the castle grounds is a very plain eighteenth-century church, modestly almost out of sight, and this is perfect.

The foundations of All Saints Church Skelton are ancient, probably Saxon and almost certainly burned down by King John. In 1325 it was rebuilt around its few possessions – some pre-Christian stone coffins and two bells, 'which have a queer, shrill tone'. One of them remains, the other is in the Victoria and Albert Museum.

In 1785 John Hall Stevenson redesigned this medieval church himself, so simply that he may only have used one of the church-kit pattern-books of the time, but, however he did it, he made it a wonder.

The church is now closed to make way for the later one in the village and is in the care of The Redundant Churches Fund and the key to view it has to be collected from a custodian who lives in an estate cottage, has a flower-bed set aside for church use, and showers visitors with fruits and vegetables from his kitchen garden, urging us passionately to come back again soon.

And his loneliness is easy to understand, for when we turn the lock in the church door we find the visitors' book with no names in it since our own of the year before. Since then no feet have walked about the worn pink slabs of the aisles except the custodian's each week as he has arranged his garden flowers in every niche on every window sill, the altar and even high up in the flimsy gallery, round the font and in the chancel. The church is severe, with perfect box pews, a three-decker pulpit with a sounding board like a halo, all bleached almost colourless by the flooding light. The altar, beneath the large clear eighteenth-century east window, is a domestic scene with a fine sofa-table as altar and a carved armchair beside it as if someone has just put down her embroidery and gone to walk among the gravestones that look in. The pulpit is the centre of the building. It stands halfway down the south side and from it the preacher can command every eye in the church – right to the back of the gallery. It faces the Castle Pew which is a large three-sided room with fireplace and barrel organ. Here the Lord of the Manor noisily stoked the fire when the sermon went on too long.

The pews have their names still – Mr Philpott, Miss Gowland – and though the ancient font has been taken to the church where Christ is a Red Indian, some old folding seats for tired or infirm godparents are there still. The walls of the church are washed a pale rose pink. They blossom with patterns of cumulus mould. A Fauconberg tomb is in the chancel, where there is one medieval 'weeping wall'. The trapped air is so still you might hear Sterne's laughter.

Outside there is, on the castle side, just in the park, a magnificent stable-block now grace-and-favour residences – but all is silent. No one about. Far across from them the

castle lies in the sun. But it is the redundant church that is the pride of the place.

In the graveyard are two most peculiar Bruegelian tombstones, mask-like, ageless faces carved by a local mason who is not sure whether he is a cartoonist or not. The heads seem bandaged up, the eyebrows beetle. They are seeing stars. Each head balances an urn on a bald pate and out of the head at the sides sprout leathery wings. One imagines Sterne and Eugenius being very taken with these.

The graveyard is beautiful. The stones tip and hob-nob together. Ivy creeps over them. The grass is long and lush, unmown enough to please Sir Robert James.

And, full circle to the coast again, you turn right off Loftus's street, past some houses with dainty hanging baskets and polished motor cars at the doors, and come to a sudden, winding stretch of road with clouds flying high above and two lines of sparkling clean little houses either side of it for maybe 500 yards. It looks like a place dropped down from Northern Ireland, and is called Cleveland Street. These are the custom-built homes of the old Liverton miners and they stand facing each other, like Nuts-in-May, all the snow-white curtains blowing. They are functional, one-storey, urban, loved, scrubbed, and each one different. The two facing herbaceous borders of chimney-pots assert that no two families were ever alike.

The road runs down into a long rough inlet that lies hidden from the cliff-tops, hidden from the pretty villages, the baronial pageants of Skelton and the sedate delights of Saltburn.

Beyond lies Skinningrove, which only ten years ago clanged and clattered with ironworkings that were strewn all over this headland, a whole city that has vanished like cleared scrap. All that remains of the Skinningrove Works are humps and troughs in the grass of the cliffs, the soft red mud.

Dotted around are shacks and sheds, old railway carriages, old chicken runs, little summer-houses with once-dainty balconies, pigeon crees with old men observing the birds. White gleams of sun catch the pigeons' wings.

Skinningrove was always eerie. It is compelling now, empty, savage. Its particularly foul slaughterhouse on the edge of the town has now been pulled down, but the river that rushes through the place and rose as a spring in the heathery moors runs bright red with 'ghorr' like foaming red ink. Ghorr is a concentrate of ironstone. On the moors it can be picked up in the hand from among the curlews and larks, like lumps of rubbery glue.

The red water froths down the village street in a deep trough. It passes an important-looking and rather fine eighteenth-century building that might have been some workhouse, or fortress against demons, but has an old painted sign on it saying Coffee House; and on the northern bank of Dante's red river of hell is a good – even beautiful – new housing estate, clean-cut, hopeful, climbing the hill. There is a proud commemorative plaque. W. S. Hicks was architect of the church above it. It has a pretty spirelet with a bulbous base and just a hint of Bavarian baroque, but looked nothing much until the rust-red clutter of the ironworkings was pulled down. Below it on the beach, near the bridge over the red river that bleeds into the sea, small fishing-boats are drawn up as they have been for at least a thousand years. Caedmon from Whitby, wandering by, would have seen a beach much the same.

Even the two terrifying Zeppelin raids in 1916 made no permanent changes to Skinningrove though airships floated from Germany like a school of whales in the sky to bomb the Benzol plant at the Works. They missed the dynamite store or it would have been another story. Some of the whales swam on to Danby High Moor and a second lot followed with incendiaries to add to the already blazing moorland. Long-dead Vikings smiled. A Zeppelin was shot down and blazed across the sea. All the boys from Sir William Turner's school ran down to the promenade in their pyjamas to cheer. I was brought up on the story of the German airmen dropping into the sea like little blazing sparklers, and my grandmother and her sisters weeping.

At Skinningrove today silent men in black oilskins stand about, not saying much. Behind them on the quay is a terrace of painted cottages. An old man comes out of one of them and walks slowly on a stick. He turns, walks back, goes home. The sea lies still. The red Kilton Beck rushes on.

Under a high sandbank on the southern side are fishermen's sheds, God knows how old, but they look older than the hills, fastened up with huge bolts and chains. Older than St Hilda. It does not do to try their doors. What would come creaking out? They are famously frightening and children run between them, fast.

In the sixteenth century a seaman or merman was washed ashore at Skinningrove. He was caught by the people and kept somewhere about the beach. He was fed upon raw fish for some days but 'at last', several sources say, 'he escaped again into his own element'.

Skinningrove people were always superstitious even by the standards of the Iron Coast, even by the standards of nearby Staithes where they still don't like putting out to sea if they meet a woman on the way to their boat. At Skinningrove they felt an abyss lurked near.

> For when the sea is calm [says Camden], the waters at Skengrave being
> spread as it were into a plain, a hideous groaning is often heard in these
> parts, on a sudden, and then the fishermen are afraid of the sea. They
> believe the ocean to be a huge monster which is then hungry and eager
> to glut itself with the bodies of men.

It is easy to see why people at Skinningrove were always afraid. Even on a fair day the sea is alert. It looms above the small white triangle of the shore, down in the cleft of the rocks. The land glares back. The Iron Coast changes. Saints and sinners, gardeners, priests, explorers, die. Sciences and religions and flying machines and heroes spring up and blossom and fade. The sea watches, swings out, swings in.

Jane Gardam
Sandwich, Kent

4 *Christ Church, Coatham, 'the spire in the sea'.
View towards Redcar and Hunt Cliff from Teesmouth.*

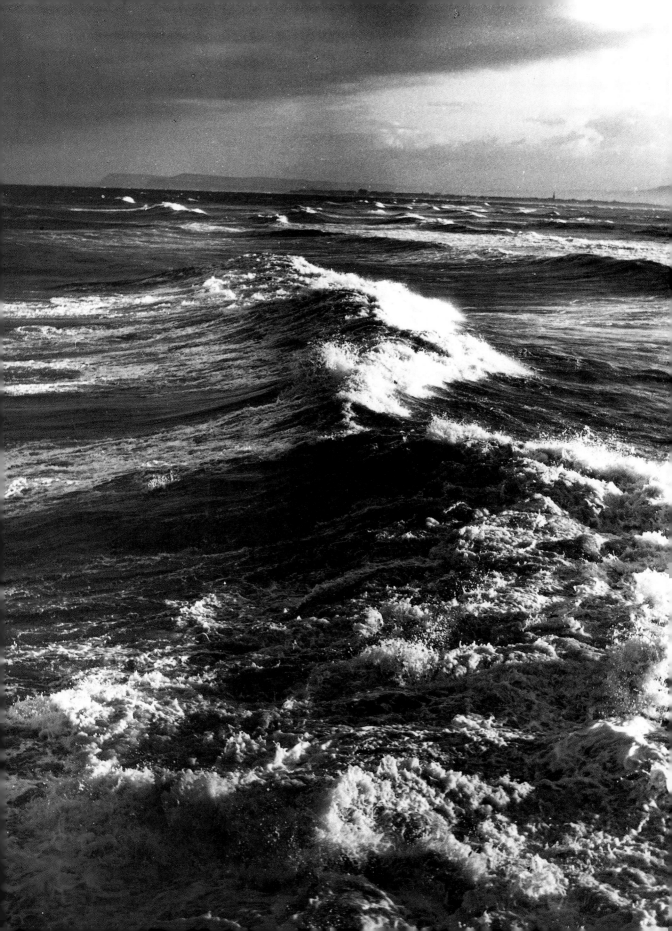

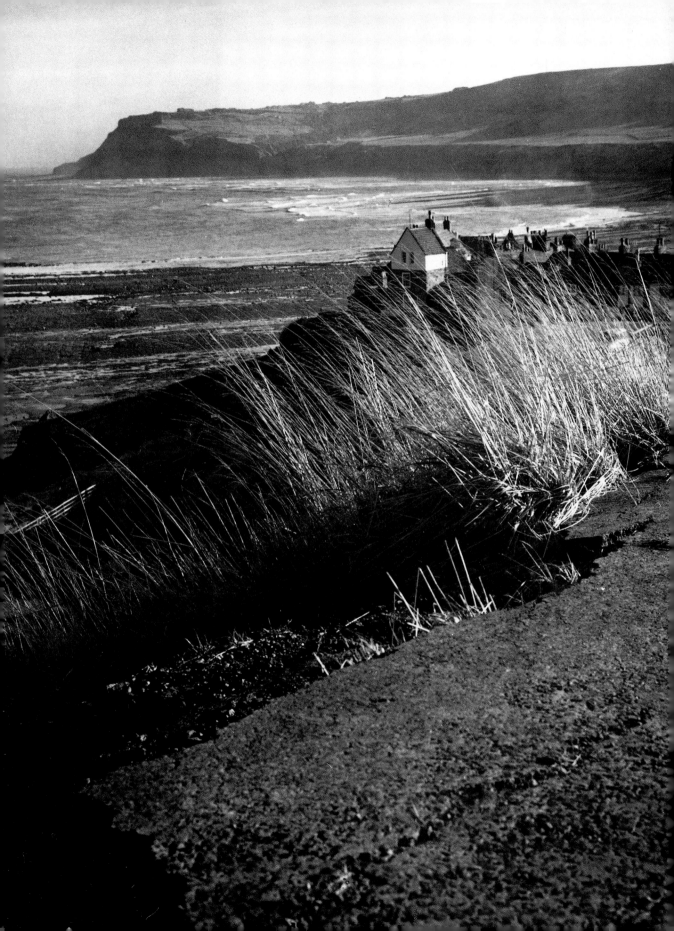

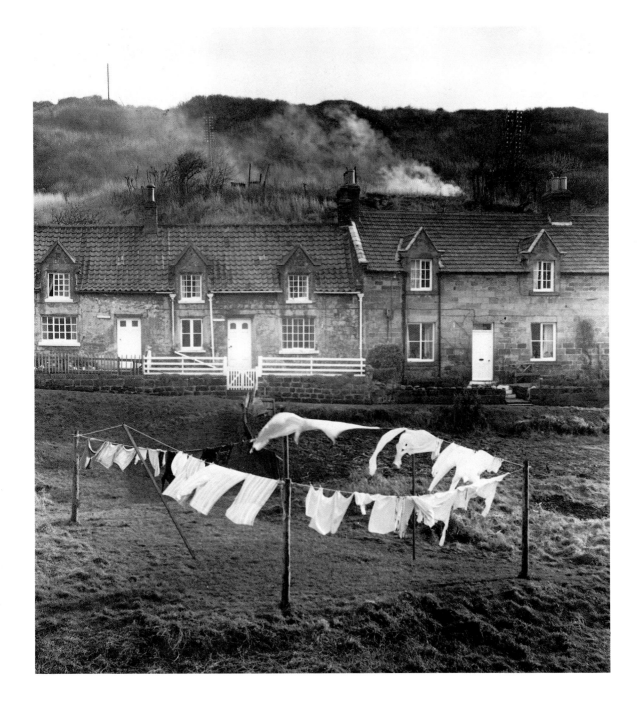

5 *Looking across Robin Hood's Bay to Old Peak, Ravenscar,*
where George III is said to have been taken to a private asylum
and treated for his madness. Here the Iron Coast begins.

6 *Sandsend, just north of Whitby,*
where jet was first mined.

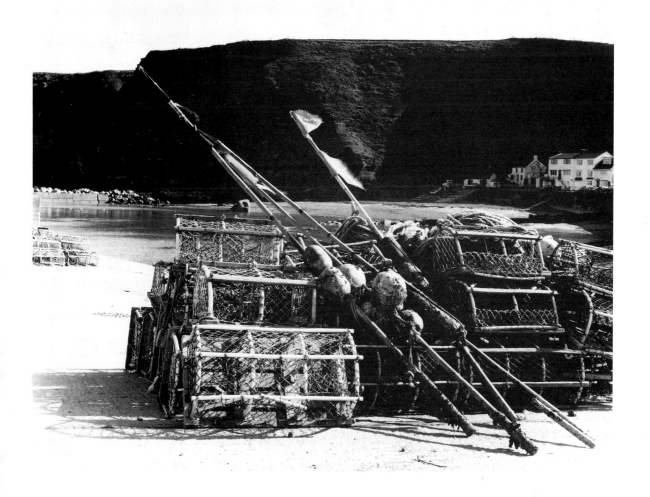

7 *Squire Barry of Fyling Hall built this nineteenth-century Ionic temple for his prize pig. Here it is being used by a local farmer for drying onions. Recently restored as a holiday cottage by the Landmark Trust. Photographed in the 1960s.*

8 *Lobster pots, Staithes.*

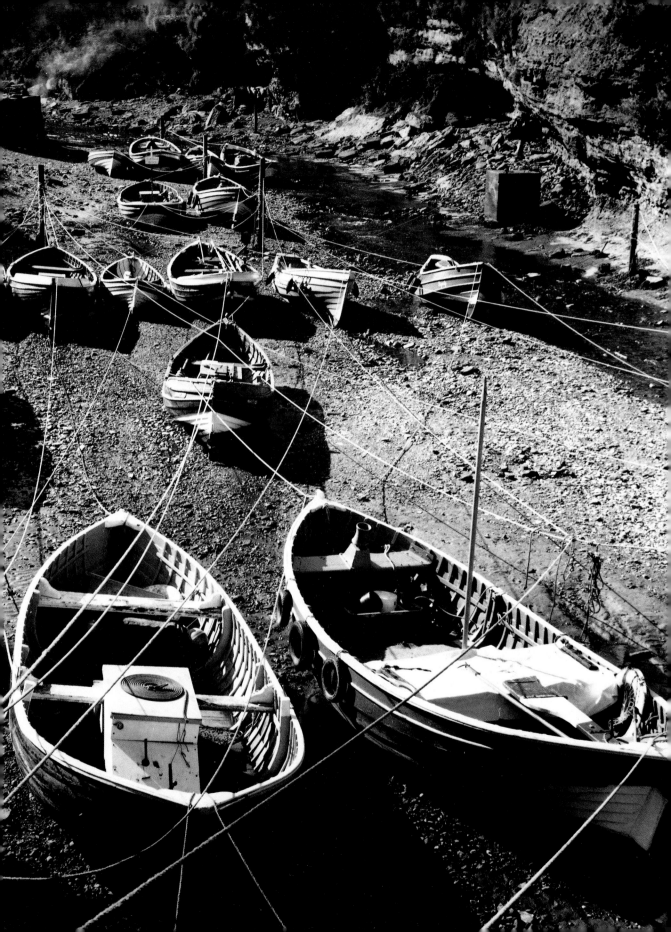

9 & 10 *Staithes cobles and fish boxes.*

11 & 12 *Village houses, many cultures, Staithes.*

REGINALD N. LEWIS.
LICENSED TO SELL BRITISH & FOREIGN
SPIRITS, WINES, ALES & TOBACCO.
TO BE CONSUMED ON OR OFF THE PREMISES.

RUSSE

13 & 14 *Pub and chapel, Staithes. The beast fell from the porch of The Black Lion in the 1960s, and broke into pieces.*

15 *Boulby Mine.*

16 *St Nicholas, Roxby,
looking towards Boulby Mine
and the sea in the distance.*

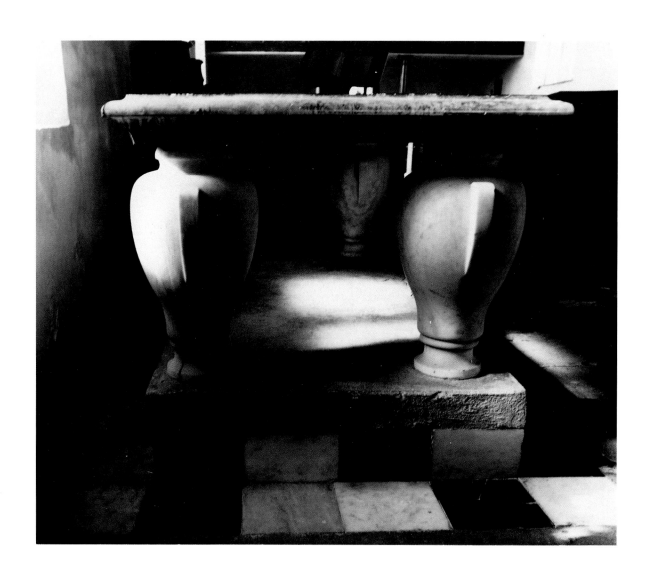

17 *The Boynton Tomb, Roxby Church, 1634. Sir Matthew carved a lengthy and beautiful inscription to his wife with his own hand.*

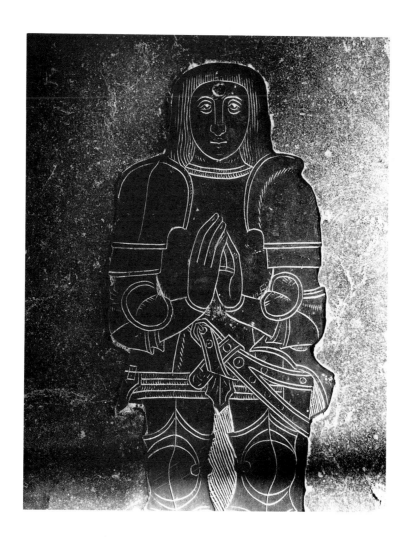

18 *Brass figure, twenty-two inches long, of Thomas Boynton, died 1523.*

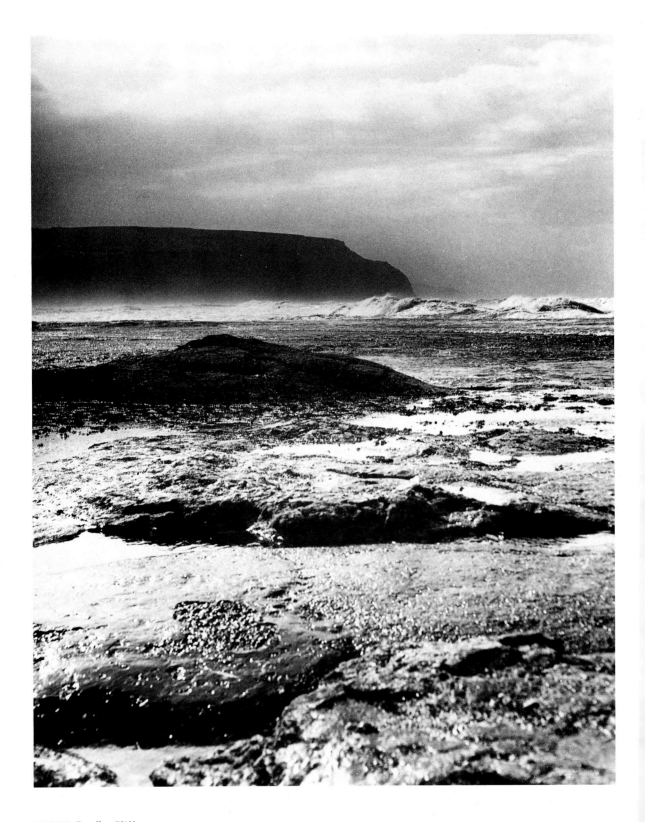

19 & 20 *Boulby Cliffs.*

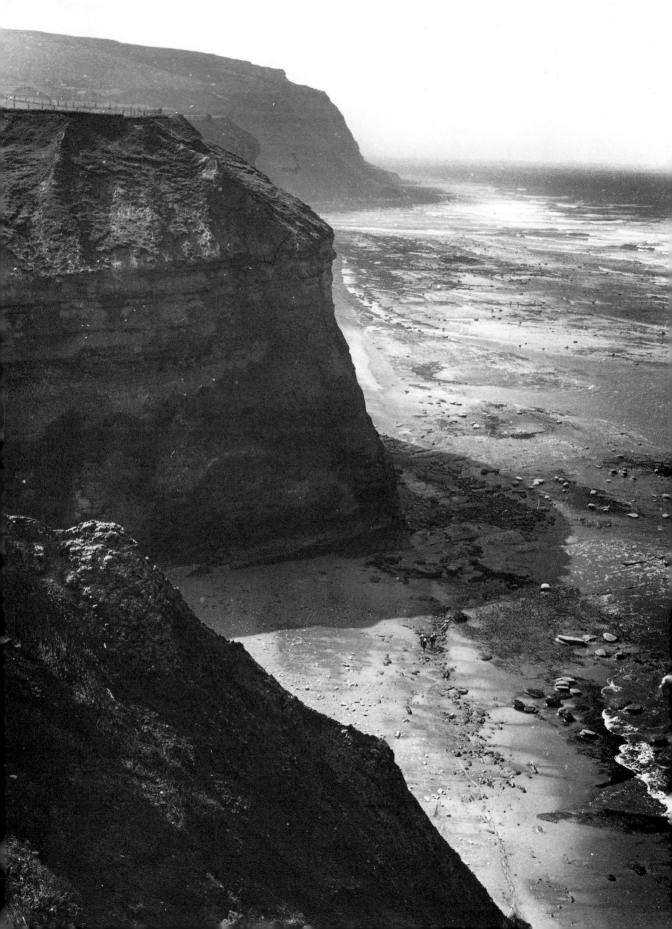

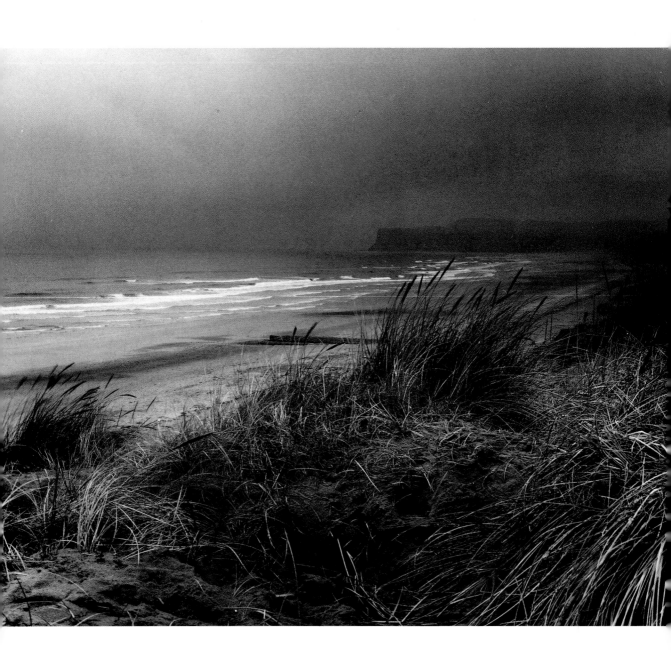

21 *View of Hunt Cliff from Marske.*

22 *Hunt Cliff from under Saltburn pier.*

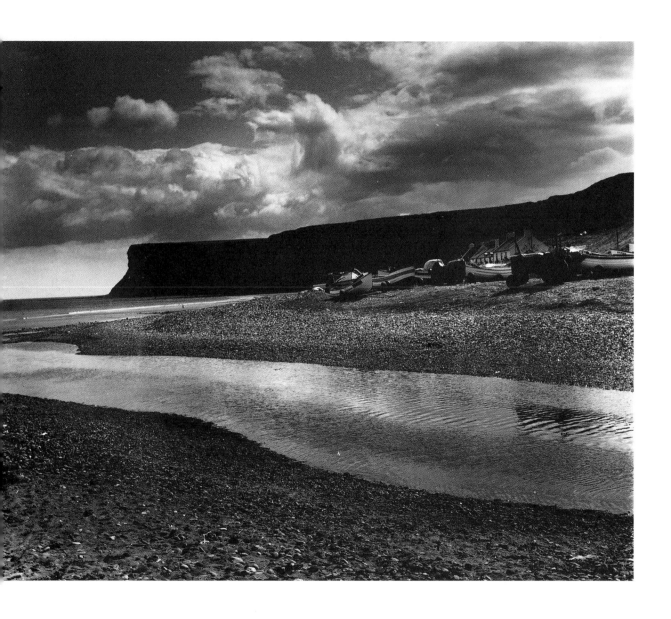

23 *The Ship Inn, Old Saltburn, under Hunt Cliff. There are smugglers' passages in the cellars to a pick-up point inland.*

24 *Coble and pier at Saltburn.*

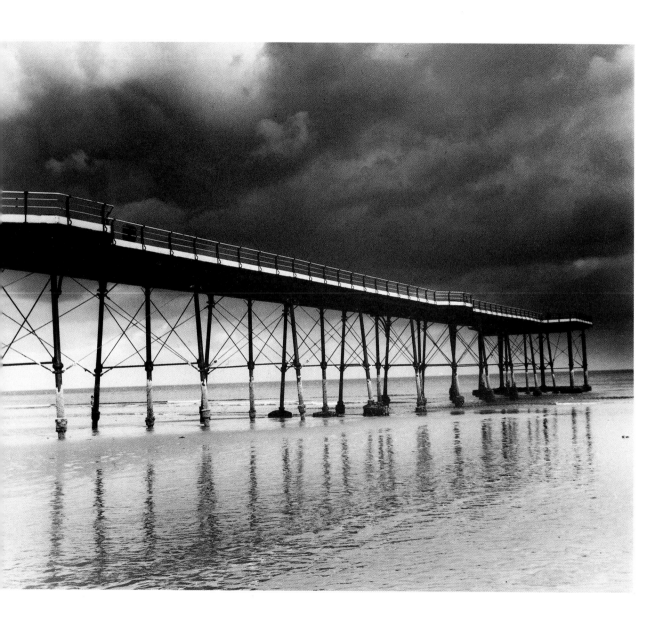

25 *Saltburn, the iron pier, one of the few unspoilt piers*
in the country, though the little theatre on the end of it blew away.

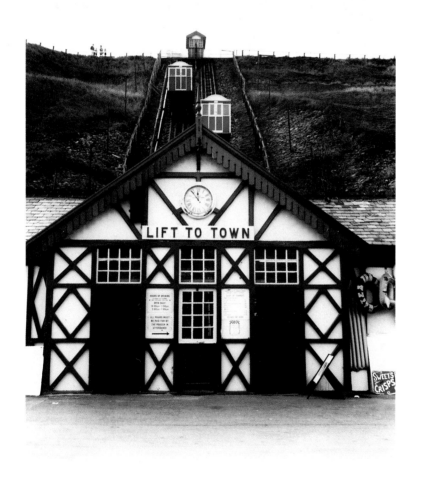

26 *'Tudor' cliff lift,*
Saltburn, still in use.

27 & 28 *Old Coatham High Street with fishermen's cottages, almost all now 'improved' and spoilt.*

29 *Sledging on Coatham Golf Course in the 1950s,*
Barker's Farm looming behind.

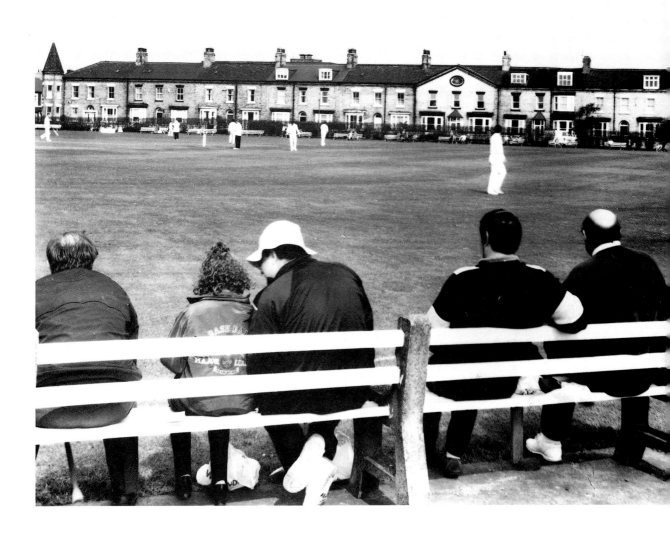

30 *Coatham cricket-field with Edwardian viewing terrace and Lady of Shallot's turret. 1990s spectators in foreground.*

31 *Red Barns, designed by Philip Webb and adorned
within by the Pre-Raphaelites. The garden had a model railway
that ran into its own glass-covered station. Here Hugh
Bell the great ironmaster ran up a ladder with the child
Gertrude Bell the explorer under his arm, but did not drop her.*

32 *The iron porch, Red Barns.
Mysterious lettering, K.K.S.*

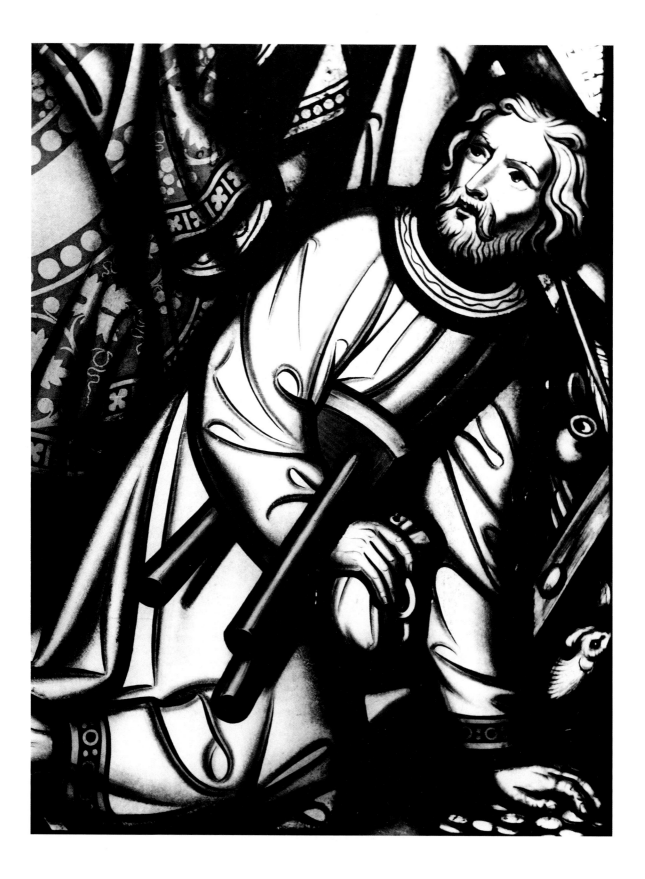

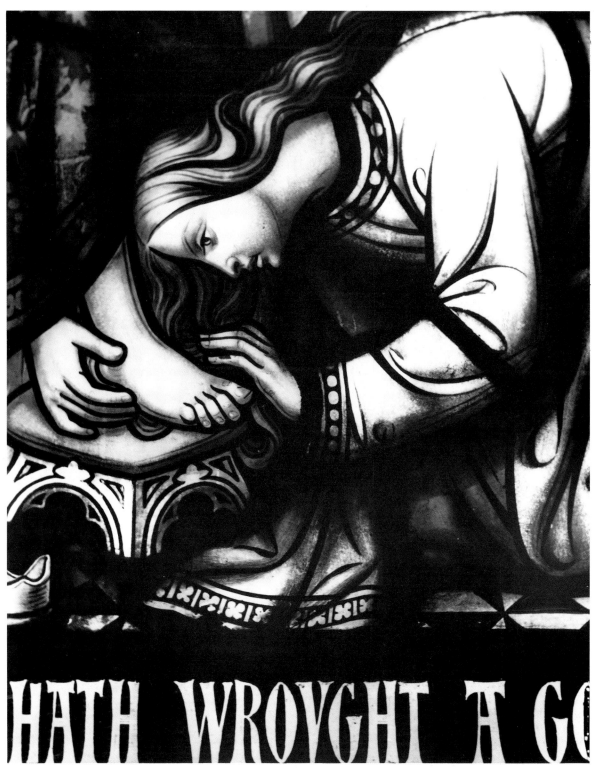

33 & 34 *Christ Church, Coatham. Detail of dazzling stained glass, 1854, by William Wailes.*

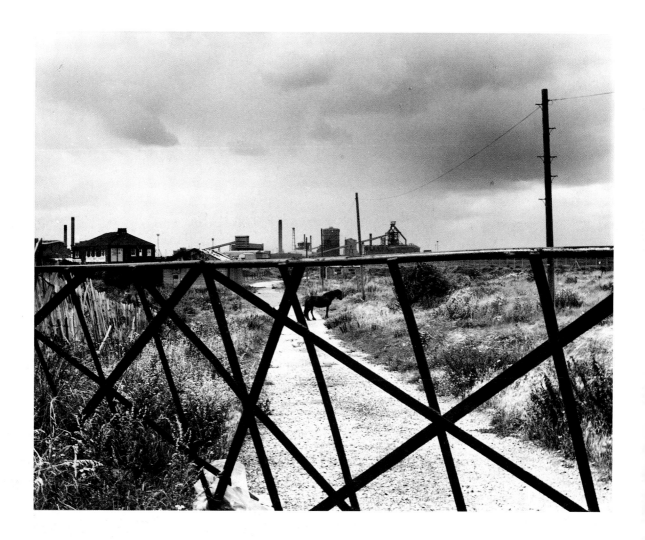

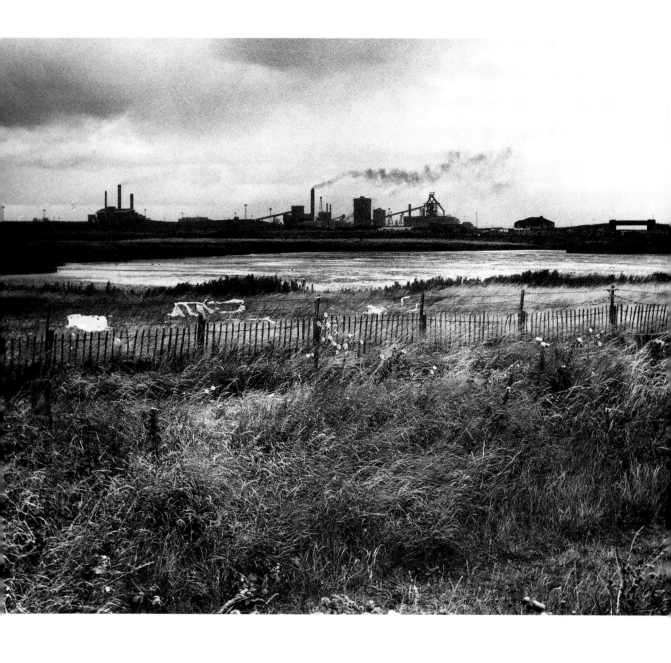

35 & 36 *Warrenby. Views over the Coatham Marshes where William the Conqueror was very nearly conquered when he and his army were lost in the sea-fret. Steelworks in the background built in the 1960s.*

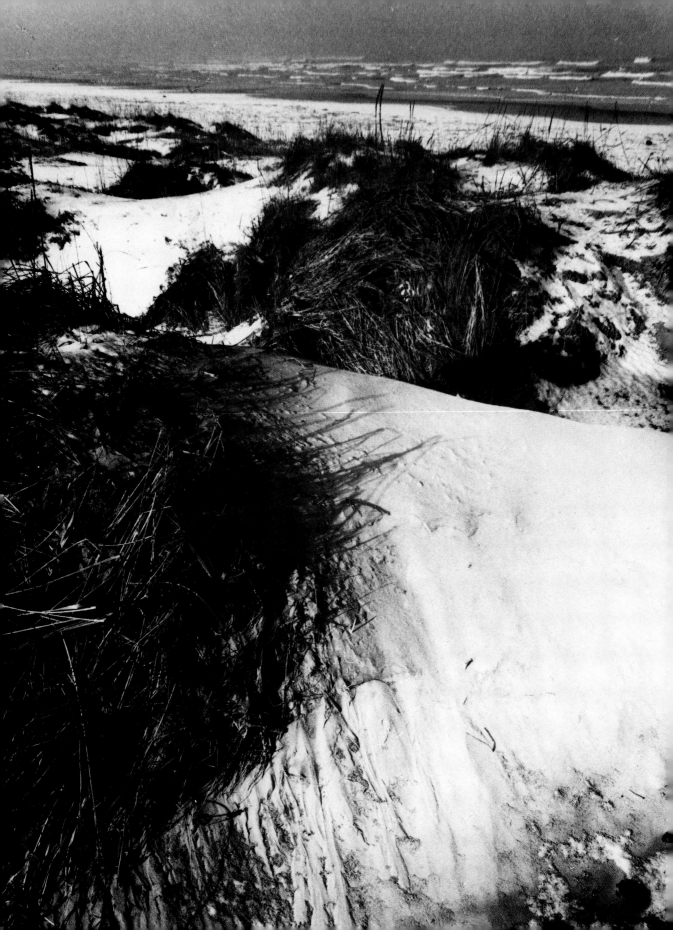

37 & 38 *Warrenby beach. Dunes in snow,*
sea lyme grass and the wild sea beyond.

39 *Sea-coal gatherers on Warrenby beach, photographed in the 1950s. Somewhere here lies the melancholy chapel of St Sepulchre's – probably a burial place. Skulls have been dug up here for centuries by fishermen digging for bait.*

40 *Furnace clinker used to build the Teesmouth breakwater. The Bloody Cranesbill usually found on Pennine limestone here flowers by the sea, the seeds brought in the limestone used as flux in the blast-furnaces.*

41 *Statue of Justice in forecourt of Kirkleatham's alsmhouses, with blackbird. Figure by Andrew Carpenter. Its scales have recently been restored.*

42 *Figure of old woman on the northern pavilion of the courtyard of the Kirkleatham almshouses, 1752, by Scheemakers. She faces an old man in an opposite niche.*

43 *Ironwork in Kirkleatham chapel,*
'the finest almshouse chapel in the world'.

44 *The chapel chandelier.*
Gilded lime-wood.

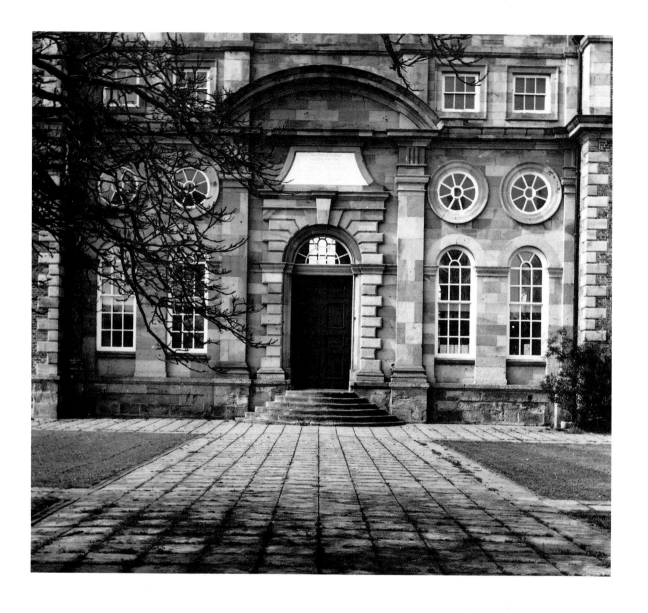

45 *Kirkleatham gatepost with Turner lion. The Turner emblem was worn on Coatham School blazers until the 1960s.*

46 *The Free School ('Old Hall') at Kirkleatham where the Turner family set up a lending library of 3,000 books for the use of the village.*

47 *Statue of Cholmley Turner, died 1757,*
by Cheere in Kirkleatham Mausoleum.

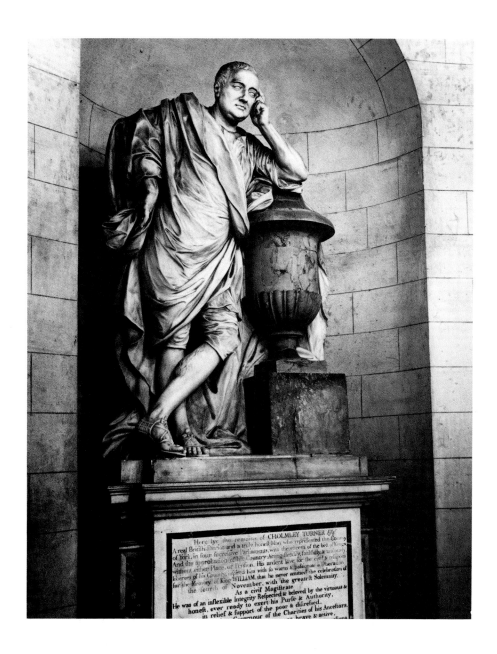

Here lye the remains of CHOLMLEY TURNER Efq.
A real British Patriot and a truly honeft Man who reprefented the County
of York, in four fucceffive Parliaments, with the efteem of the beft of King
And the approbation of his Country Acting fteadily, faithfully, & zealously
without either Place, or Penfion. His ardent love for the civil & religious
liberties of his Country, infpired him with fo warm & paffionate a Veneration
for the Memory of King WILLIAM, that he never omitted the celebration of
the fourth of November, with the greateft Solemnity.
As a civil Magiftrate
He was of an inflexible integrity Refpected & beloved by the virtuous &
honeft, ever ready to exert his Purfe & Authority,
in relief & fupport of the poor & diftreffed:
of the Charities of his Anceftors,
brave & active,

48 *Kirkleatham Mausoleum. An octagonal building*
by James Gibbs, 1740, at his most Baroque. The design
is based on the campanile of San Biagio
at Montepulciano in Tuscany.

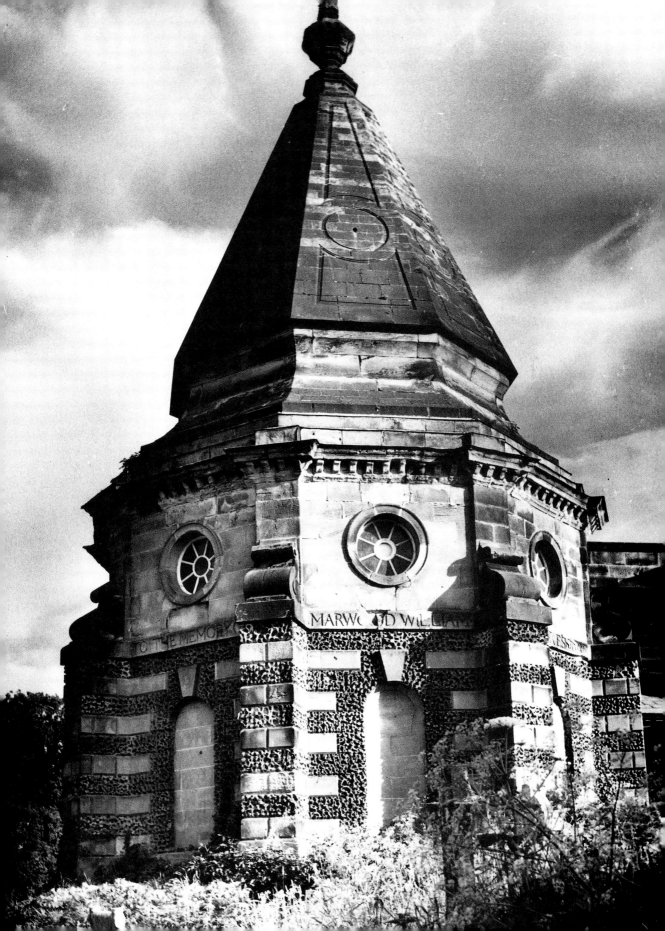

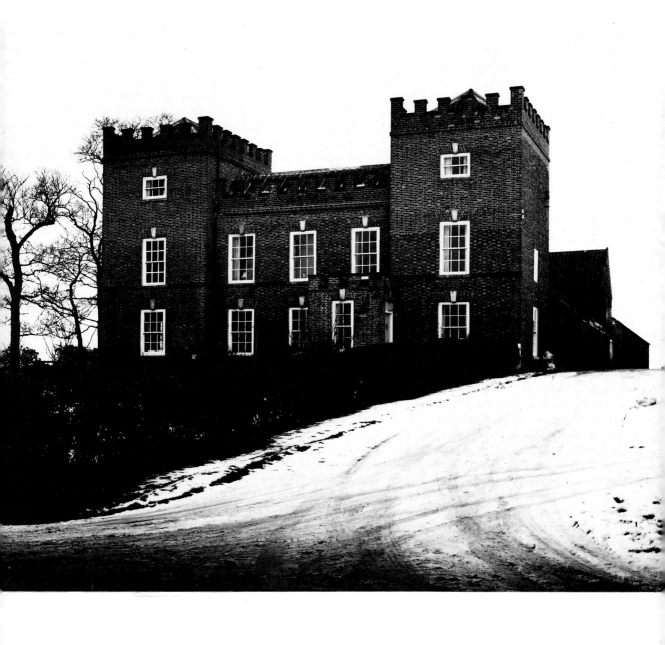

49 *Eye-catcher. Castellated farmhouse built to delight the viewer from Kirkleatham Hall.*

50 *Eye-catcher in the wheat. The Gothic dovecote. It had crenellations and spiral staircases and split windows for doves, not arrows.*

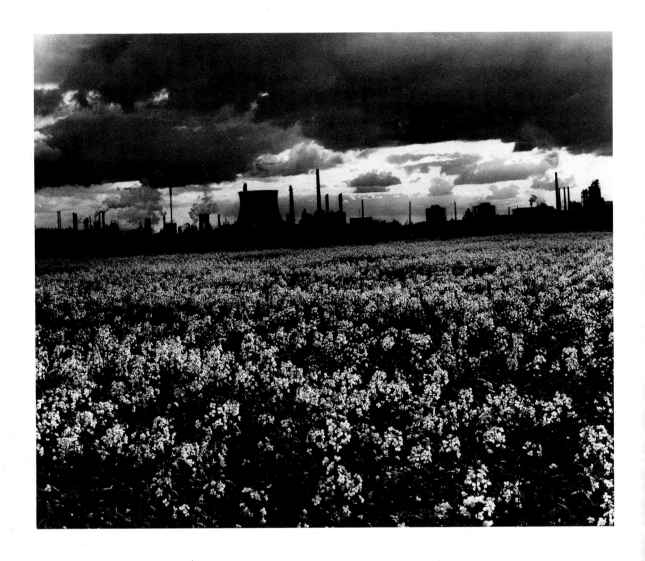

51 *ICI and oil seed rape.*
The Wilton works, seen from Kirkleatham.

52 *Sea-lyme grass and the Old Iron Works of Dorman and Long.*
They were demolished in the 1960s.

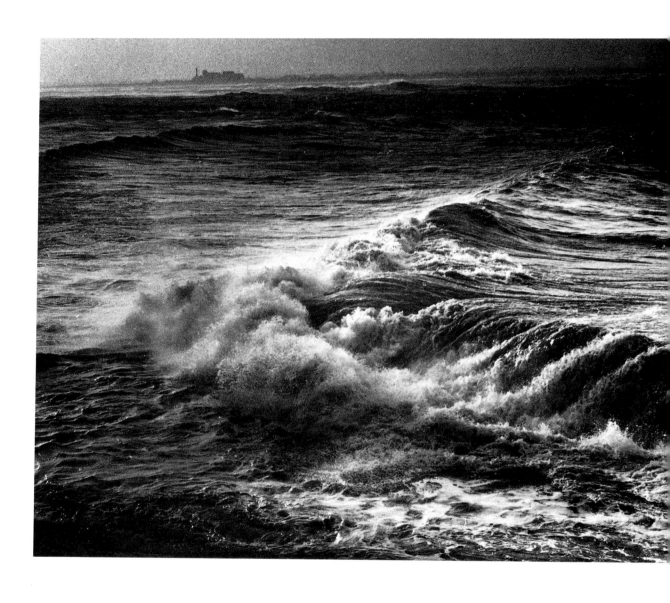

53 *The northernmost corner of the Yorkshire coast looking across the Tees from South Gare.*

54 *The same on a wild day.*

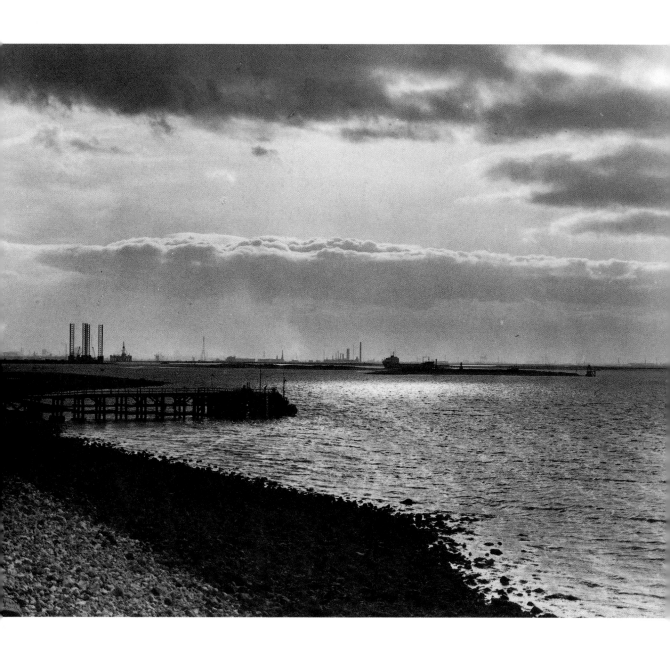

55 *Teesmouth.*

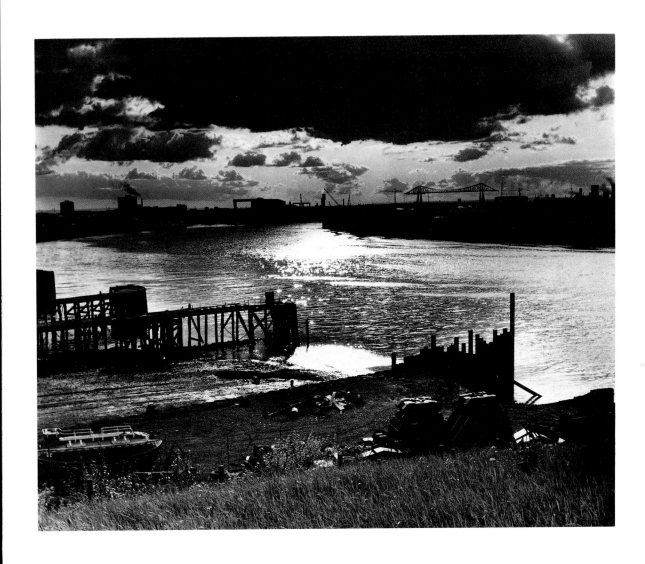

56 *Looking from Grangetown towards Middlesbrough and the Transporter Bridge. Grangetown, considered to be the unhealthiest town in the world, has an artificial hill created as a belvedere on the site of the Old Works. A corncrake sang in the field behind.*

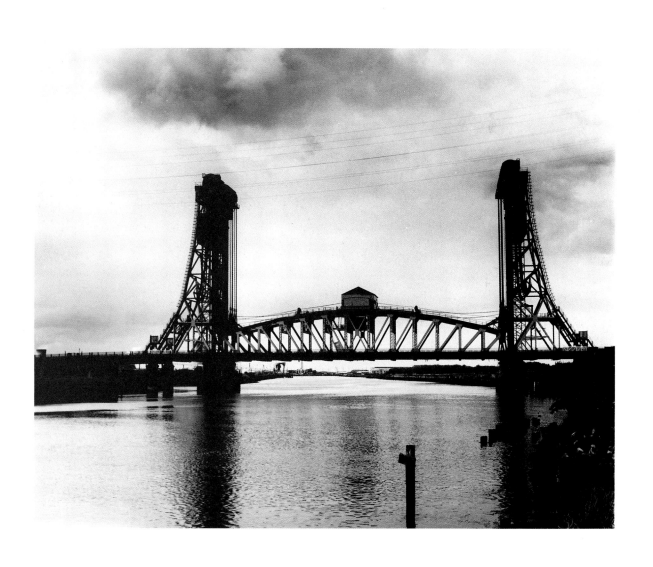

57 *The Newport Bridge, Middlesbrough,*
built by Dorman Long in the 1930s.

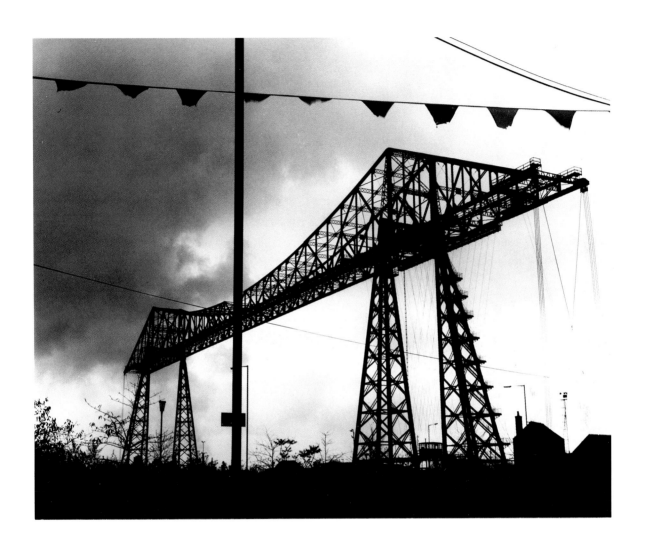

58 *The Transporter Bridge, Middlesbrough, opened in 1911, the largest of this kind in the world, and still working.*

59 *Middlesbrough, Bell Brothers' offices, which became Dorman and Long. Saved from demolition by local conservationists. This is Philip Webb's only commercial building. 'It is of a remarkable daring in the choice of motifs and the freedom in their handling.' Pevsner.*

60 *Middlesbrough Exchange, 1866, demolished, but the heads saved and redistributed.*

61 & 62 *Ormesby Hall, real acanthus in the garden,*
stylised in the upper hall.

63 *The goddess of Plenty hovering over Roseberry Topping, a cow and a cottage, above the staircase of Ingleby Arncliffe Hall. Eighteenth-century plasterwork.*

64 *Roseberry Topping itself, near Great Ayton, is the best known landmark of the Cleveland Hills.*

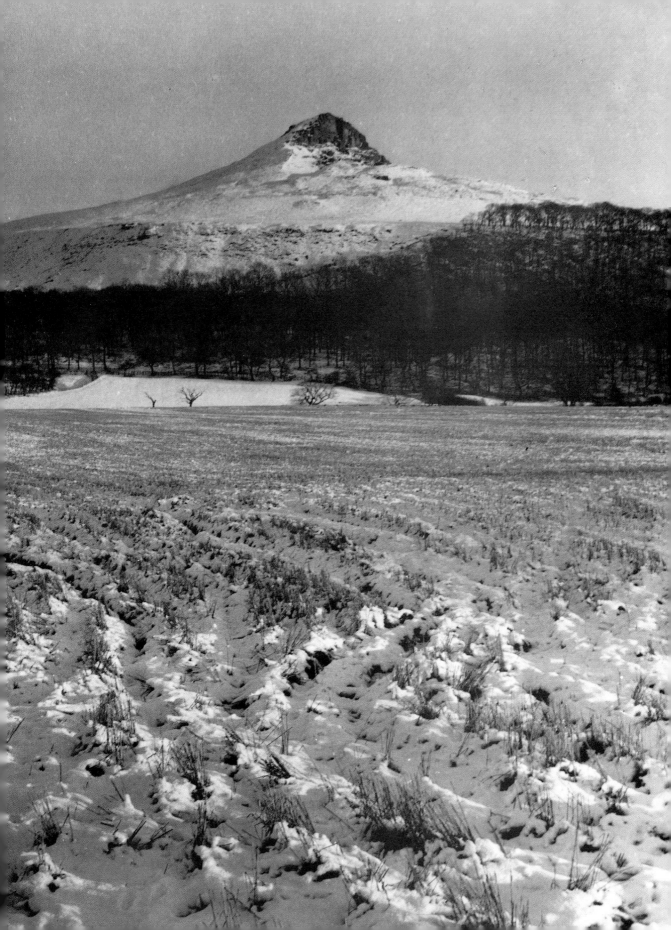

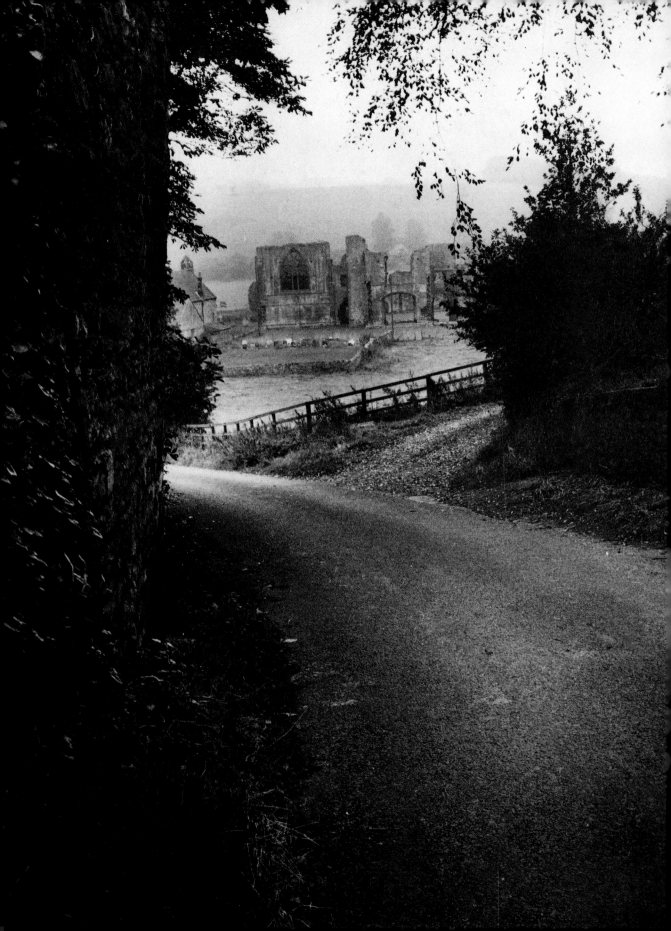

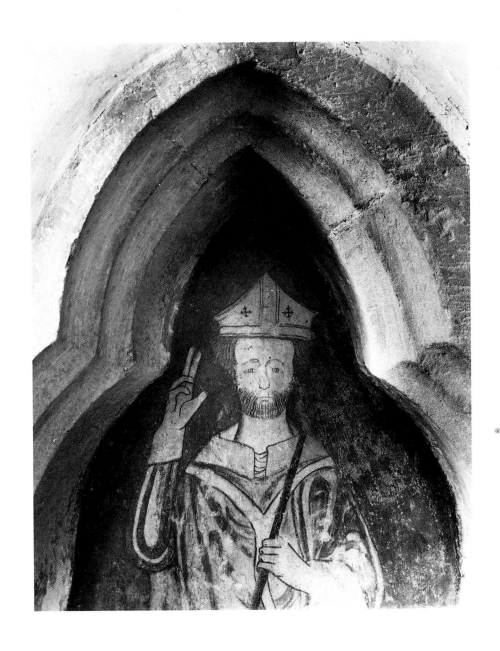

65 *Easby Abbey ruins.*

66 *Church of St Agatha of Sicily, Easby.*
Thirteenth-century wall painting of Archbishop.

67 *St Nicholas, Richmond, the front.*
The colonnade and the parapet were added
by Ignatius Bonomi in 1813.

68 *Beehives in the orchard.*

71 & 72 *Glasshouse with ancient vine, and shed with flowerpots, St Nicholas.*

71 & 72 *Glasshouse with ancient vine, and shed with flowerpots, St Nicholas.*

73 *Immense blue seat at the top of the long herbaceous border, St Nicholas.*

74 *Lady in a garden. Detail of seventeenth-century embroidered fire screen in St Nicholas.*

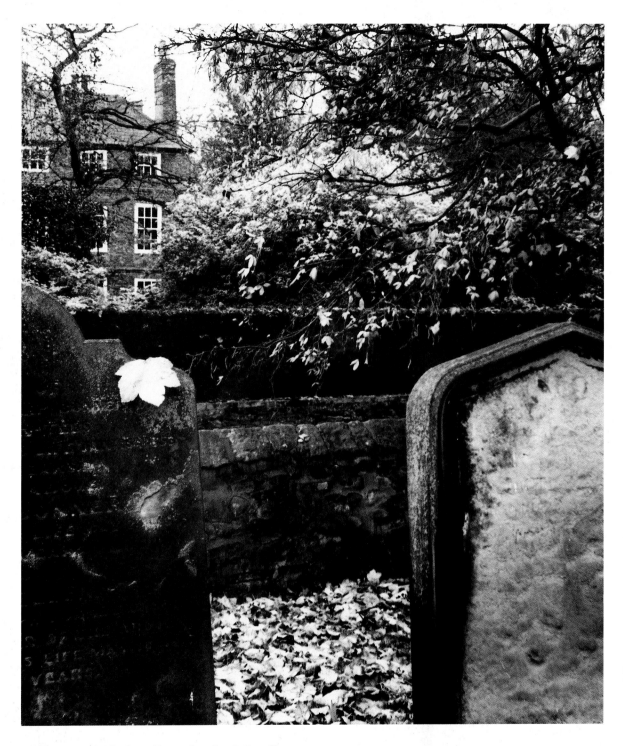

75 *The rectory at Croft-on-Tees, where Lewis Carroll grew up.*

76 *One of the Trods or Pannier Ways which are a feature of the North York Moors. Most are probably medieval in origin and built by the Abbeys. Coal, iron and stone were the main heavy loads over the centuries. This one is photographed near Egton Bridge.*

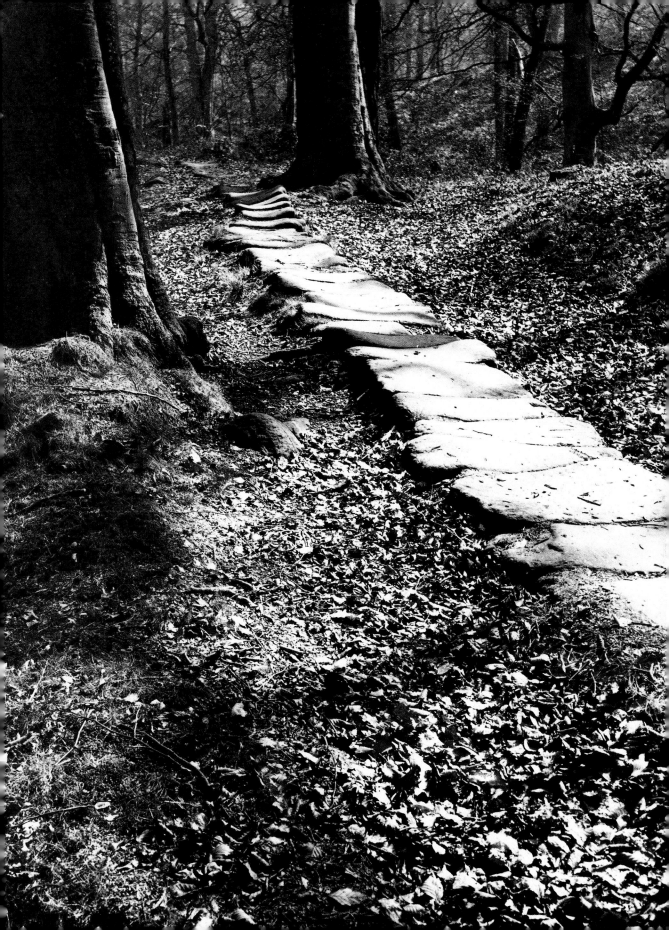

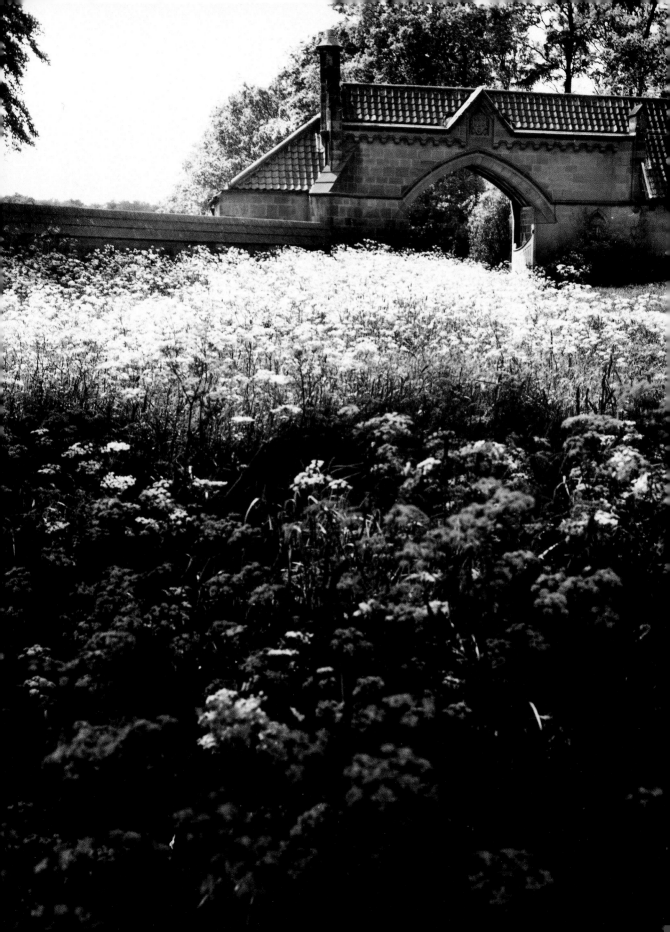

77 & 78 *Rounton Grange. Philip Webb's gatehouse rising above the Queen Anne's lace, and his coach house, now used as a stonemason's yard. The Grange was demolished in the 1950s.*

79 & 80 *The sad water garden at Rounton Grange.*

BENEFACTIONS.

1678 William Young charges the yearly sum of £
46 payable out of certain closes called Buck Bank,
the Croft, Great Lands, the Moor or broat closes
in Great Ayton, late belonging to Isaac Martin,
by half yearly payments on the 24th June and
the 25th D... ...iety thereof to be
applied in purchasing Clothing for the Poor,
and the other Moiety for Putting out as an
Apprentice the Child of a poor person belonging
this Township.

Elizabeth Bulson by her Will devises a
...ce or parcel of Meadow ground containing three
...the Township of Falsgrave in
...applied for the benefit of the
...r of this Township, the present rent is £9.

...ree Cottages Situate in Great Ayton were
...ed by Voluntary Contribution for the use
...e Poor of this Township.

10 June 1828 Francis Sanderson}
William Barker. }Churchwardens.

81 & 82 *The old church of All Saints, Great Ayton, Captain Cook's family church.*

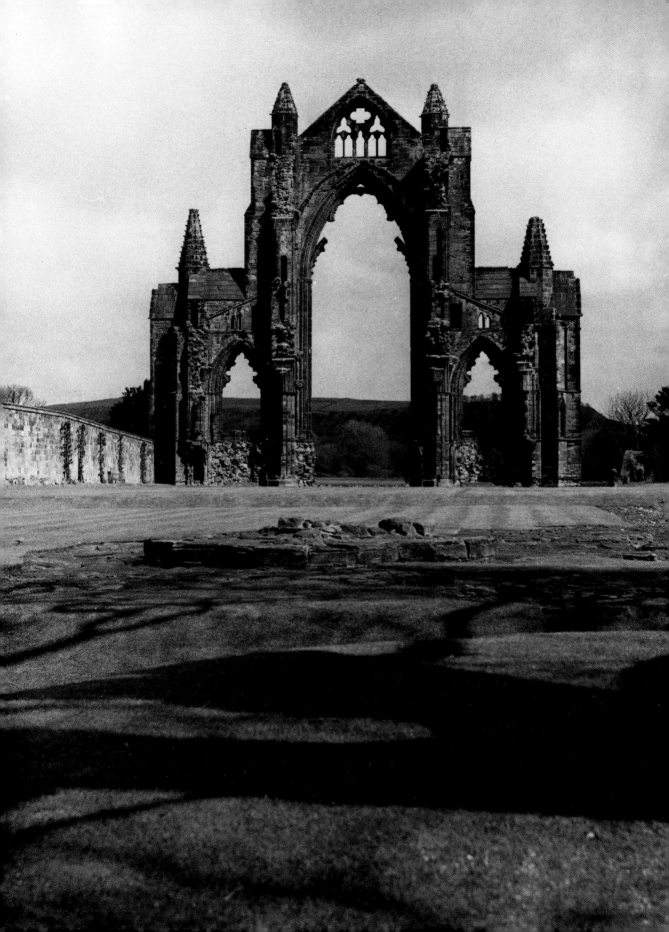

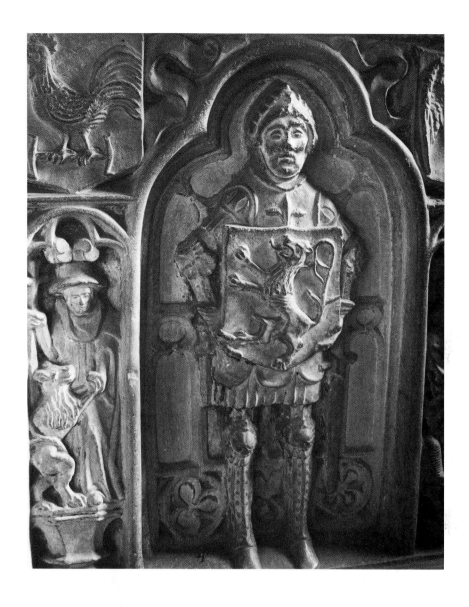

83 *Guisborough Priory, the 100-foot-high east wall.*

84 *The Brus tomb in Guisborough Parish Church, originally in the Priory. Early sixteenth-century motif of Prior Cockerell top left.*

85 & 86 *Rosedale iron mines, with sheep. The detail
shows the old kilns of 1861 which were used for calcination
of the ore, making it easier to transport.*

87 & 88 *Wheeldale Moor. The Roman road linked the signal stations on the coast with Malton and York.*

89 *Skelton Castle in the mist.*

90 *The old churchyard, Skelton.*

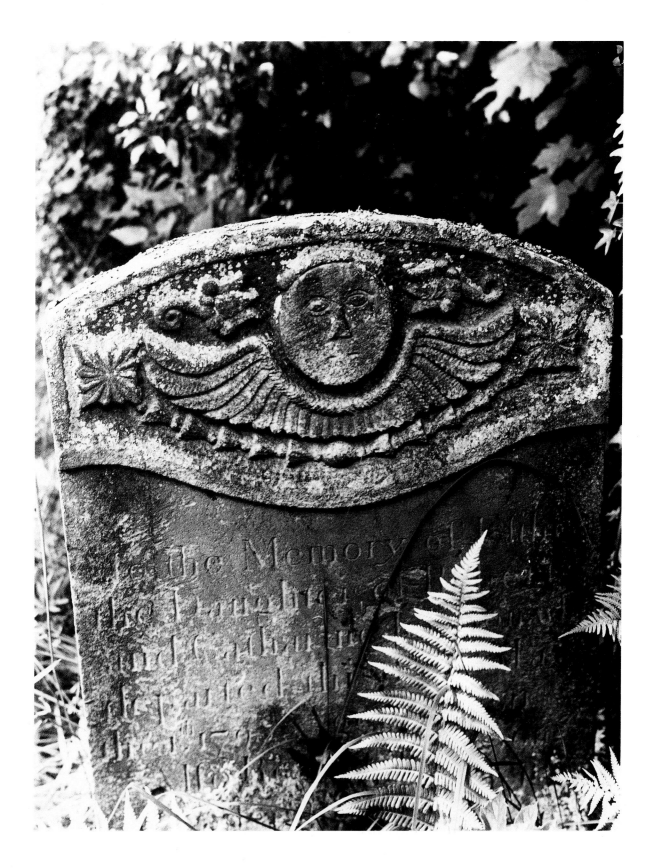

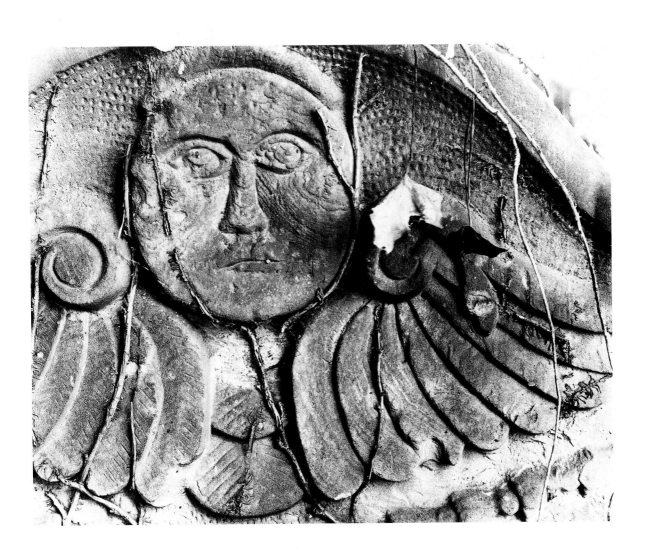

91 & 92 *Angels and queer faces on tombstones at Skelton.*

93 & 94 *Skelton Old Church, with eighteenth-century box pews and triple-decker pulpit, in the care of the Redundant Churches Fund.*

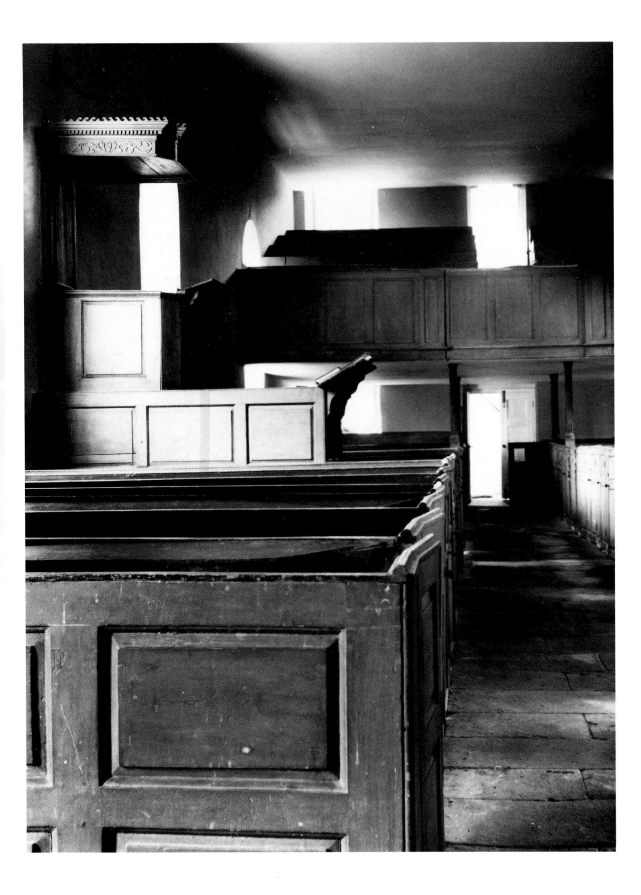

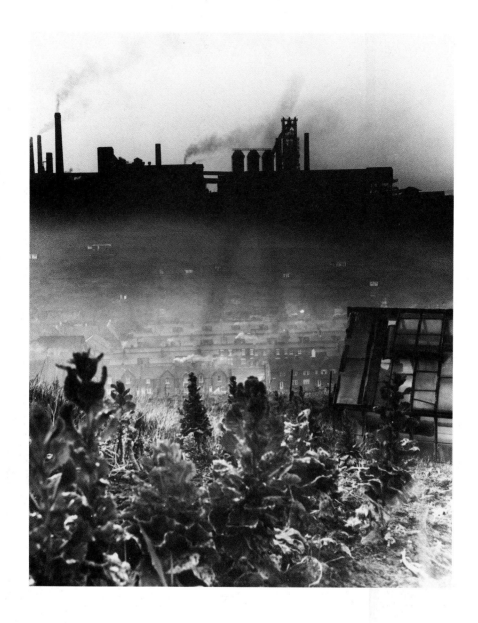

95 & 96 *Skinningrove. Ironworks – now gone – allotments and pigeon crees, fishing boats and terraces, that survive.*

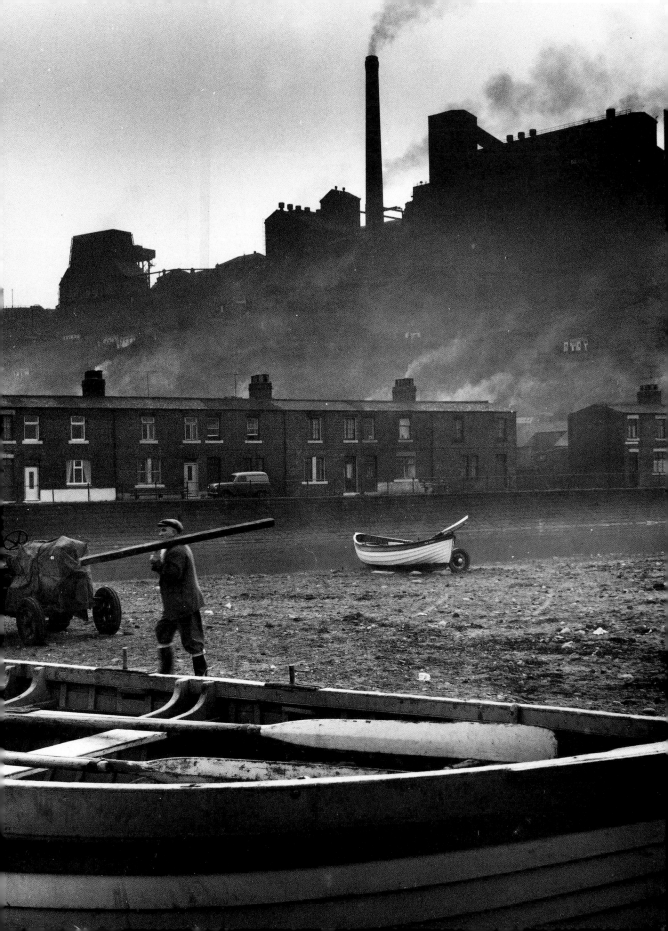

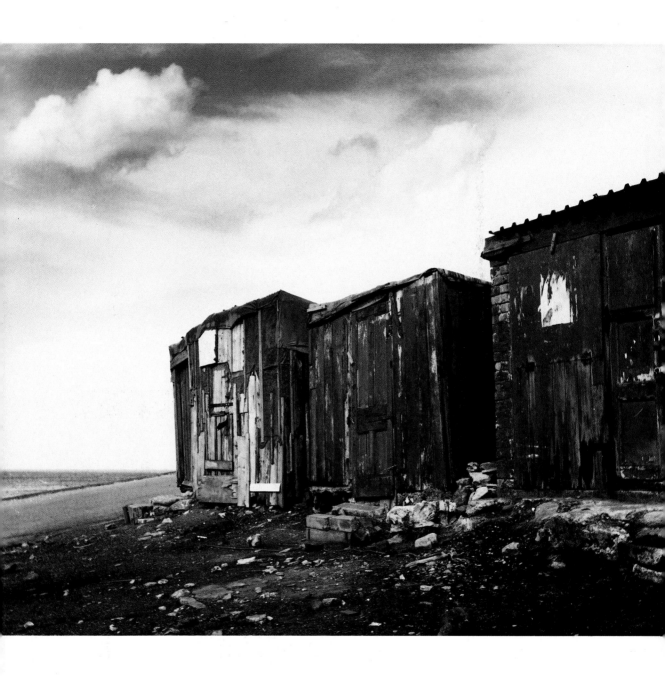

97 *The Skinningrove huts.*